UNTOLD TALES

of the

BOSTON

IRISH

Peter F. Stevens

THE
History
PRESS

Published by The History Press
Charleston, SC
www.historypress.com

Cover images courtesy of the Library of Congress.

First published 2021

Manufactured in the United States

ISBN 9781467147071

Library of Congress Control Number: 2020945748

Notice: The information in this book is true and complete to the best of our knowledge. It is offered without guarantee on the part of the author or The History Press. The author and The History Press disclaim all liability in connection with the use of this book.

To Winnie Liang,
With more love and gratitude than I can possibly express.
Because of you, I'm the most fortunate of men.

CONTENTS

CONTENTS

CONTENTS

Acknowledgements

This book is a compilation and expansion of columns I have contributed to the *Boston Irish Reporter* and now *Boston Irish Magazine* over the past decade, as well as new material. As both a writer and editor for the newspaper and the magazine, I have the ongoing privilege of working with publisher Ed Forry, editor Bill Forry and editor Tom Mulvoy, three of the best in the business and three of the best friends anyone can have. All have given me free rein to write about topics that have often fallen between history's proverbial cracks.

No one can set out to write about the Boston Irish without calling on the peerless and prolific author Thomas H. O'Connor, the late professor of history emeritus at Boston College. His work *The Boston Irish: A Political History* stands as a benchmark of Boston Irish history. Also at Boston College, the Burns Library's splendid Irish collections have been integral to me on this and many other projects and articles.

Authors Mike Quinlin—founder of Boston's Irish Heritage Trail—and Dennis P. Ryan have delved into the city's vibrant and oft-controversial past to preserve the story of the Irish in these parts. John McColgan, Boston City Archivist, has few rivals in his immense knowledge of all that was and is Boston Irish.

As always, I treasure the support of Peg Stevens, Karen Stevens, Greg Stevens and Val Doran, and Paula and Joe Axelrod. I also want to thank Jonathan and Rachel Ng.

My deep thanks go out to Mike Kinsella, The History Press editor, and Rick Delaney, The History Press copyeditor, for their spot-on efforts on the book.

Part I

JUSTICE DENIED

"THOU SHALT NOT SUFFER A WITCH TO LIVE"

Ann "Goody" Glover

At Our Lady of Victories Church (currently closed), perched on Isabella Street in Boston, is a plaque testifying to a dark day in the annals of the Boston Irish. The memorial marks the saga of Ann "Goody" Glover, an elderly Irishwoman who was hanged on November 16, 1688, as a witch near the site of the future Catholic shrine. As the tablet notes, she is considered by many to be a Catholic martyr in Massachusetts, executed because of the Puritans' fear and hatred of "Papists." The Irishwoman's trial and death served as a chilling portent of the Salem witch trials some four years later.

The traditional yet murky details of Goody Glover's story are as follows.

On November 16, 1688, jeers erupted from hundreds of throats. An ox-drawn cart flanked by sentries creaked to a stop in the shadow of a huge elm tree. A gaunt woman, staggering from the weight of the chains that tore her wrists and ankles, stepped from the cart. Her guards shoved her beneath a noose dangling from the elm.

A jowly man clad in a long black robe and a high, wide-brimmed hat held up his hand for silence. The throng's din ebbed, no right-minded Puritan wishing to suffer the ire of Superior Court Clerk Dr. Benjamin Bullivant.

A few feet from the tree, a chained woman clutching a cat sobbed. Her mother, Ann "Goody" Glover, was about to die at the end of a rope. Goody Glover's only crimes were her Catholicism and her Irish brogue. In Puritan Boston, they were reason enough to hang.

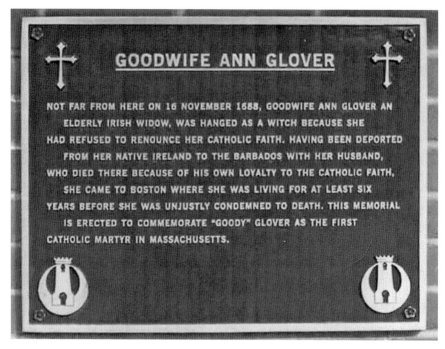

Memorial plaque at Our Lady of Victories Church, in Boston, for Ann "Goody" Glover, tried, convicted and hanged for witchcraft in 1688. *Photo by Peter F. Stevens.*

Goody Glover and her daughter, Mary, had arrived in the Massachusetts Bay Colony as refugees of the religious wars ravaging Ireland. In court, Ann Glover said that she and her husband had been sent from Ireland as slaves to Barbados during Oliver Cromwell's brutal campaign in Ireland. Glover stated that while in Barbados her husband was "scored [whipped] to death, and did not give up his religion, which same I hold to."

In Boston, as a "bondswoman," or indentured servant, Mary Glover, Ann's daughter, toiled as a washerwoman for "a sober and pious Puritan mason, John Goodwin." One of Goodwin's children, thirteen-year-old Martha, accused the Irish servant of stealing linen sheets. Neither of the Glovers reportedly spoke much English, but Ann Glover confronted Martha Goodwin, allegedly unleashing a stream of "barbarous Irish" and "very bad language" in defense of her daughter.

Shortly afterward, John Goodwin rushed to Cotton Mather, the Puritan cleric and leader, and charged that Goody Glover, "a scandalous Irish Papist," had driven the Goodwin children into "odd fits." Mather immediately suspected Glover of witchcraft.

Constables seized the Irishwoman from her rude cottage, clapped her in irons and flung her into a squalid cell in Boston Gaol, whose three-foot-thick brick and stone walls rose on Prison Lane.

From July to early November 1688, she languished on the fetid straw atop her cell's floor. Two Puritans—Robert Calef and Rebecca Nurse—brought her food and clothing when the jailers allowed. Calef later wrote a scathing attack against Cotton Mather for his persecution of Glover and other alleged witches. Rebecca Nurse, convicted of witchcraft, would hang in Salem in 1692.

Goody Glover's trial began in the second week of November 1688 and degenerated into one of the cruelest farces in American legal history. Forced to defend herself in Gaelic, which none of her accusers understood but which several court-appointed officials "translated," she faced a range of charges: flying in and out of chimneys, striking children deaf and dumb, casting "hellish spells" and practicing "black magic." One of the most serious charges was "Satanic idolatry"—she had been seen kneeling in front of a tiny statue of the Blessed Virgin. In a chilling prelude to the Salem witch trials, Glover's chief accusers were children.

The ministers, officials and "skilled physicians" denounced Glover as "a vile Papist hag." A judge wrote: "Upon her trial, the Papist did in Irish confess to herself guilt. The Papist defended herself unskillfully in her foreign gibberish and admitted her witchcraft."

When asked whether she was a Papist and when shown "an idol [statue of a saint] that was diabolic," she said, "I die a Catholic." The Puritans would contend that she admitted to tormenting the children by striking small rag dolls that were produced during the trial. When she took up one of these dolls in court, one of the afflicted children was seized with fits. In reality, though, Glover failed to comprehend the questions hurled at her.

Her accusers also claimed that the night after her trial, Glover's jailers heard her "explaining to the devil that she had confessed everything because he had deserted her." Upon examination by court-appointed physicians, Glover acknowledged her Roman Catholicism and recited the Lord's Prayer "very readily." She was sentenced to "be swung off into eternity."

According to one onlooker, "a great concourse of people came to see the Papist hag hang on the morn of November 16 [1688]….The hag's cat, the witch's familiar, was present, fearsome to some. They would to destroy the cat, but Mr. Calef would not allow it." The final chapter of Goody Glover's harsh, tormented life unfolded, her fate terrible testimony to the

simmering paranoia that would soon engulf New England and would begin the infamous Salem witch trials of the 1690s.

Her noose affixed around her neck, Ann Glover predicted that her death would not erase the children's "fits," as she had cast no spells. Moments later, the noose pulled tight.

The "Great Elm" no longer stands to remind passersby of the torturous path of the Irish in Boston and the sad fate of Ann "Goody" Glover.

Glover's trial and execution are incontrovertible historical facts. Scholar Liam Hogan, however, contends that she was not an "Irish slave," that she was never in Barbados and that her Catholicism was not the driving factor of her fate in Puritan Boston. His research into the foggy (at best) historical record does raise debate on the first two points. Still, his belief that it was solely Puritan terror about witchcraft and not at all about Glover's religion that sealed her death belies one incontrovertible fact: Cotton Mather's Boston was a hostile spot for Irish Catholics.

THE ST. PATRICK'S DAY MURDERS OF 1845

Homicide on a Holy Day

On the Hanover, Massachusetts, Historical Society's July 2000 calendar, an old photo showing a house and shed and bearing the inscription "Three Irishmen Shot Here by Seth Perry in 1845" was featured. What had started as a St. Patrick's Day celebration for three Irishmen working for the Old Colony Railroad to build a track from Boston to Plymouth ended in an explosion of violence.

In the early afternoon of March 17, 1845, the trio of Irish laborers—James Stapleton, Patrick Stapleton and Pierce Dowlan (Dolan)—strode with other workers from a jobsite near Hanson to a "noted groggery" in Hanover. The Irishmen's plan was to celebrate their "old sod's" patron saint on his holy day.

Neighbors loathed the "shanty," run by fifty-two-year-old local Seth Perry; he had been arrested and jailed several times for serving liquor without a license. After a few rounds, Patrick Stapleton and Pierce Dowlan started to argue with a man named Enos Bates, Perry's cousin. Words fueled by liquor escalated to blows between Stapleton and Bates, and soon, the brawl ended up outside the shanty. Suddenly, a musket pealed. Stapleton toppled dead to the ground, Seth Perry standing nearby with the smoking weapon—and reloading.

Most of the Irish railroad workers scattered in every direction, but not James Stapleton and Dowlan. James lunged at Perry. For a second time, the musket belched flame and smoke. The ball tore into James Stapleton's chest and killed him instantly. As Dowlan started to run, Perry, with another

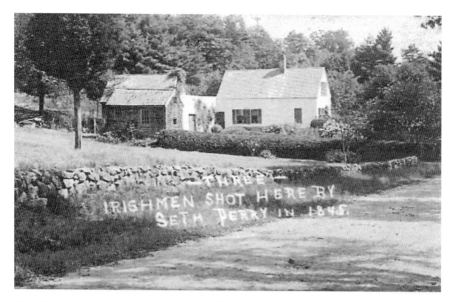

Site where two Irish laborers were murdered by Perry on St. Patrick's Day in 1845. *Courtesy of Hanover, Massachusetts Historical Society.*

musket close by, picked it up, leveled it and fired. Dowlan must have turned. The round slammed into his face, shattering his jaw. He would survive the grievous wound.

Later that night, a mob of temperance zealots likely motivated by their hatred of alcohol rather than any sympathy for the two dead Irishmen and their wounded companion destroyed the shanty and were about to burn down Perry's house when constables stopped them. Because St. Mary's, in Quincy, Massachusetts, was the sole Catholic church between Boston and Hanover at the time, the brothers Stapleton were buried in unmarked paupers' graves in the church's graveyard.

Seth Perry was indicted by a Plymouth County grand jury on April 14, 1845, charged with two counts of murder and one count of assault with intent to kill. He languished in a cell without bail as both the "prosecution and defense petitioned the court to try Perry for the murders of Patrick and James Stapleton together, but the court denied their request, and ordered that Perry be tried first for the murder of Patrick."

Few Irish immigrants believed Perry would be convicted. The disdain that many New Englanders heaped on the "ragged Irish" of the era was rife with brutal stereotypes of "drunken Paddies." Nativist newspapers and magazines were clotted with other ethnic caricatures of "Paddy and Bridget."

On June 17, 1845, Perry stood trial in front of a twelve-man jury. It was truly a jury of his peers, as not one Irishman was among them. The verdict came two days later. Perry was found guilty of manslaughter only in the death of Patrick Stapleton. Historian John Gallagher notes: "The district attorney dismissed the charge of murder in the death of James Stapleton when Perry agreed to plead guilty to manslaughter. The prosecutor chose not to pursue the charge of assault with intent to murder Pierce Dowlan."

If Perry had cut down two "native New Englanders" and wounded a third, he might well have been hanged. Still, given the unbridled contempt so many Yankees harbored toward the Irish, the verdict must have surprised many locals. As Mr. Gallagher noted in his letter to this author, Thomas O'Connor, in *The Boston Irish: A Political History*, writes that the Irish of the era were viewed by Yankee Protestants as "little more than 'wild bison' ready to leap over the fences that usually restrained the 'civilized domestic cattle.'"

"Wild bison" notwithstanding, Perry's sentence was ten years for killing Patrick Stapleton and three years for the murder of James Stapleton. From June 28, 1845, until his release in 1858, Perry was incarcerated in the grim stone and brick Charlestown State Prison. He went back to Hanover, where he died on November 25, 1874. No one knows the exact spot where he was buried, the murderer sharing the same fate in death as the two Irishmen he had slain.

At 1359 Broadway in Hanover, the house that Seth Perry's groggery flanked remains. The combination of brogues and too much St. Patrick's Day revelry ignited something murderous in Seth Perry, something so dark that even his Yankee neighbors could not ignore one savage fact: he had gunned down two men and wounded a third. Irish though those men were, and even though Yankee prosecutors and a Yankee jury could not bring themselves to convict Perry of outright murder, they held him to some account, even in a day of antipathy toward the Irish.

HISTORIAN AND RETIRED BOSTON Police superintendent John Gallagher, the author of *Rum, A Tailor's Goose and a Soap Box: Three Murderous Affairs in the History of Hanover, Massachusetts*, provided several key details.

3
"HIS DUTY WAS DONE TO THE LAST"

Officer John T. Lynch

F or God's sake, keep him away and don't let him shoot me again!" shouted Patrolman John T. Lynch at Officer John P. Doyle. Doyle had rushed across icy, snow-cloaked Arch Street to the corner of Summer and Kingston Streets as three shots pealed through the chill evening air of January 16, 1908.

Lynch's muscular, six-foot, two-inch frame pinned another man to the ground. In the man's right hand was a smoking .38-caliber revolver. "I saw Lynch on top of a man, holding the hand that grasped the revolver, and turning it away from him," Doyle later said to reporters.

A crowd had begun to gather.

As Lynch rolled off the gunman, Doyle pounced on him and pushed the revolver farther away from him. Twenty-three-year-old John Lynch lay crumpled and writhing in the snow from a bullet that, according to the later police report, "had entered the right side of the officer above the liver and entered into the vitals." Despite the grievous wound, Lynch had refused to let the shooter escape.

While grappling to control the thrashing suspect, Doyle shouted at onlookers to summon an ambulance and a police wagon from the Court Street Station. All he could do until help arrived was to urge his brother officer to hold on. "I jumped in to help and had no idea at first that Lynch was wounded. I supposed the shots must have missed, but as I jumped on the man, Lynch rolled over and I saw he was hurt," Doyle later told the *Boston Post*.

John T. Lynch had departed his family's home, 11 Bainbridge Street, in Roxbury, at 5:00 p.m. on Thursday, January 16, 1908, for his evening shift. For Lynch, wearing the blue and the badge of the Boston Police Department was his lifelong dream; less than a week earlier, he had made the jump from a reserve officer to a full-time patrolman, "owing to the fine work" that had caught the attention of his superiors.

Heads of Police Department Also Attend Funeral of Patrolman Lynch Today.

Heroic Boston Police officer John T. Lynch, who made the ultimate sacrifice to arrest an armed burglar in January 1908. Boston Post.

Lynch was born in Boston on August 13, 1880, in the Lowell Street home of his parents, James and Mary Lynch. He grew up with three brothers and two sisters in a close-knit Irish Catholic family, graduated from the Phillips Grammar School and attended English High School for two years. Leaving school to help with the family's finances, he went to work for several years at a local grocery store and then landed a job as a clerk for Andrew J. Lloyd & Company, an eyeglass firm. He learned to repair glasses there but longed for a life with more adventure.

His yearning for a more physical career surprised no one who knew Lynch or knew of him. Long before he donned police blue, he was renowned as one of the finest athletes in Boston, starring in track and crew. The *Post* noted: "He was a charter member of St. Joseph's Athletic Association, West End....He represented that organization in all branches of sport in the various track meets of this part of the country and was stroke of the famous St. Joseph's crack four-oared crew of three or four years ago. Cups that Lynch won for his organization and banners and shields that he helped win now number among the most cherished trophies in the possession of St. Joseph's Association."

When Lynch turned eighteen, he enlisted in the Ninth Massachusetts Infantry and soon earned renown as one of the regiment's finest sharpshooters. He mulled re-upping in the army, but his desire to become a Boston police officer brought him back home. "Lynch was a man of magnificent physique," a *Post* reporter wrote, "standing 6 ft. 2 inches, in his stockings and tipping the beam at about 200 pounds. For years he cherished the ambition to become a police officer and at the age of twenty-three successfully passed the examination for the police service.

"He was compelled, however, to wait for two years before he could receive his appointment. He continually looked forward to the day when he would be made a police officer."

That day came less than a week before he encountered the gunman at the corner of Summer and Kingston on January 16, 1908.

At roll call, Lynch and fellow patrolmen were ordered to stay on the lookout for a notorious South Boston gang that had been robbing downtown stores in recent weeks. According to the *Post*, "owing to the numerous breaks by 'yeggmen' [armed burglars] in the business section, officers on the beats were ordered to watch closely for suspicious characters." Just a few hours earlier, two or three yeggmen had reportedly hit a clothing store at 364 Washington Street.

Lynch began his rounds in Winthrop Square that frigid night and worked his way to Summer Street. Patrolman Doyle headed up to Arch Street.

An hour or two into the shift, Lynch stopped short at the corner of Kingston and Summer Streets. He "noticed two suspicious men in a doorway" and asked them what they were doing and what their names were.

One of them, slightly built and barely five feet, five inches tall, stepped onto the sidewalk and muttered that he was "John Murphy" of Andrew Square, South Boston. "As he [Murphy] passed, Patrolman Lynch felt him for articles, as is the custom." The man was clean.

Lynch nodded and said: "I guess you are alright. You can go along."

The officer turned to the second, who hesitated in the shadowy doorway and murmured that his name was "Foley."

As Lynch moved closer to frisk the man, "Foley" slipped a revolver from his overcoat's right hip pocket. Three flashes illuminated the corner, and three sharp cracks echoed above Summer and Kingston. One bullet slammed into Lynch's arm, and another whistled over his shoulders.

The other shot ripped into his right side, dug through his abdomen and lodged in his liver.

Murphy vanished into the night.

Lynch somehow wrapped his arms around Foley, took him down and wrestled for the revolver. Foley tried to twist away, but the wounded officer would not let go.

Passersby began to stop around the two men. Fred Shubert, of 191 Auckland Street, Roxbury, tried to help Lynch. "I rushed to the scene and arrived at the same time as Patrolman Doyle," Shubert testified. "I saw Officer Lynch on top of the man…holding the latter's right hand in which there was a revolver."

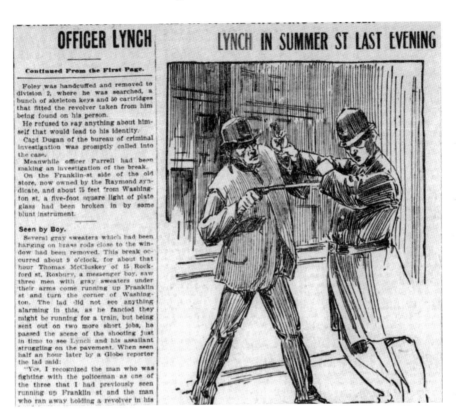

OFFICER LYNCH

LYNCH IN SUMMER ST LAST EVENING

Continued From the First Page.

Foley was handcuffed and removed to division 2, where he was searched, a bunch of skeleton keys and 50 cartridges that fitted the revolver taken from him being found on his person.

He refused to say anything about himself that would lead to his identity.

Capt Dugan of the bureau of criminal investigation was promptly called into the case.

Meanwhile officer Farrell had been making an investigation of the break.

On the Franklin-st side of the old store, now owned by the Raymond syndicate, and about 75 feet from Washington st, a five-foot square light of plate glass had been broken in by some blunt instrument.

Seen by Boy.

Several gray sweaters which had been hanging on brass rods close to the window had been removed. This break occurred about 9 o'clock, for about that hour Thomas McCluskey of 15 Rockford st, Roxbury, a messenger boy, saw three men with gray sweaters under their arms come running up Franklin st and turn the corner of Washington. The lad did not see anything alarming in this, as he fancied they might be running for a train, but being sent out on two more short jobs, he passed the scene of the shooting just in time to see Lynch and his assailant struggling on the pavement. When seen half an hour later by a Globe reporter the lad said:

"Yes, I recognized the man who was fighting with the policeman as one of the three that I had previously seen running up Franklin st and the man who ran away holding a revolver in his

This newspaper artist's dramatic sketch of Officer Lynch's struggle with gunman appeared a day after Lynch was shot. Boston Post.

As an ambulance and police wagon rattled up to the corner at about the same time, Doyle "got the wristers" (handcuffs) on Foley, picked him up with several other officers and tossed him into the wagon. Meanwhile, Patrolman Bartel and other Station 2 officers carried Lynch from the street on a stretcher, loaded him carefully into the ambulance and raced off to the Relief Station Hospital (part of the old Boston Hospital, Harrison Avenue).

Inside the vehicle, Lynch asked Bartel for something to kill the pain but then, according to Bartel, "seemed to fall into a stupor and did not speak again until he was being carried into the hospital."

The *Post* reported: "He was then carried upstairs to the operating room, where he was laid on the operating table. The doctors held a consultation and decided to remove the bullet from the wound. The flow of blood from the wound was very small."

The surgeons went to work, probing the wound for the bullet and gently extricating it. By the procedure's end, they knew that the damage was fatal.

As the doomed officer came out of anesthesia, he started to sit up. His doctors and nurses gently held him down. His eyes widening, Lynch asked, "Am I all in, doctor?"

One of the surgeons replied, "No, officer, I guess you will be all right in a little while."

One of the team told reporters: "This answer seemed to cheer him, and he smiled. Then with a pitiful, mournful voice he [Lynch] said: 'Oh my poor mother, what will she say....'

"These were the last words which the officer spoke, for he then lapsed into unconsciousness, from which he never awoke."

Patrolman John T. Lynch passed away at 10:40 p.m., before his mother and father could arrive by his bedside. Standing beside Lynch was Captain Gaskin, of Division 2, who had gone to the hospital as soon as word of the shooting came in. Gaskin trudged downstairs to address the throng of reporters in the lobby.

"Patrolman Lynch was one of the best young officers I ever knew and had a brilliant record," Gaskin began. "He was a careful man, polite and ever ready to do his duty. It is one of the saddest things that I have ever known during my time in office. His duty was done to the last in holding a dangerous man, even though dying."

Inside a Station 2 cell, Foley, related the *Post*, "held a moody silence until word came that Patrolman Lynch was dead.

"'Foley,' they [the police] said to him as he peered from behind the bars at them.

"Officer Lynch is dead. You are a murderer. The electric chair will fix you for this."

Stunned and furious, Lynch's comrades in blue began combing every lead about Foley, twenty-four years of age, and quickly discovered "that he had no home...that he lives in South Boston and that he is a member of a bad gang."

Officer John P. Doyle, who had scrambled to Lynch's aid and grabbed the gun from Foley's grasp, fought back tears as he spoke to reporters. "I am too much broken up to tell you how badly I feel. It seems strange that such a new man should have been stricken down. I do not remember the man who did the shooting, but he must be one of the gang we have been looking for lately."

Meanwhile, Lieutenant Smith, Captain Dugan and Captain Gaskin interrogated the prisoner, reminding him that the electric chair awaited him. "Then the man seemed to lose his nerve," the *Post* recounted. "He talked."

While the police interrogated Foley and started to comb South Boston for additional leads, the press descended on Patrolman Lynch's home. The *Post* reported, "There his sorrowing family was found....Nearly crazed with grief over the untimely death of her favorite son, who thought only of her in his dying moments, the mother of the dead officer was on the verge of prostration.

"Sinking into a half-swoon on being told the awful news, she was not herself for the rest of the evening. Her cries, together with the weeping of the dead man's sisters, could be heard throughout their home all of the evening—the home that the dead officer left about 5 o'clock last evening in the fullest health and hoped to return to at 1 o'clock this morning."

Lynch's brother officers felt the same array of emotions but for the moment tamped down their grief. That would come full bore later. They continued to press Foley.

Within hours, the gunman completely cracked. He told the police that his vanished accomplice was a man named John Murphy.

On January 18, 1908, the *Post's* front page blared, "Police Get Pal of Robber Who Killed Officer." The city's papers reported: "They were waiting in the doorway [at the corner of Summer and Kingston Streets] to pounce upon the first best chance to waylay a pedestrian. [Foley] knew he could not get by the search of the officer, and he had fired, not with the intention of killing him, but for the purpose of diverting the officer's attention so that he could get away. He expressed sorrow for Lynch's death."

Murphy's actual name turned out to be Lawrence, and Foley's was Smith. With Lawrence fingering Smith as the killer and with Smith having been caught literally with gun in hand, the police and prosecutors moved quickly in Boston Municipal Court. Smith had been a career criminal since the age of eleven and had served two stints in prison.

Patrolman John T. Lynch's funeral Mass was held on Monday, January 20, 1908, at Saint Joseph's Catholic Church on Circuit Street, in Roxbury, at 9:00 a.m. Packing the pews were his family, friends, brother officers and dignitaries. Outside, a dense crowd had gathered in the frigid morning air. "Great sorrow for Patrolman Lynch's untimely end was expressed in all parts of the city," the *Post* noted. "His relatives are heart-broken, while the members of the police department, superiors and brother officers, manifested great grief."

Following the service, Patrolman Lynch, an army veteran, was interred with full military and civic honors at Holyhood Cemetery in Brookline, Massachusetts.

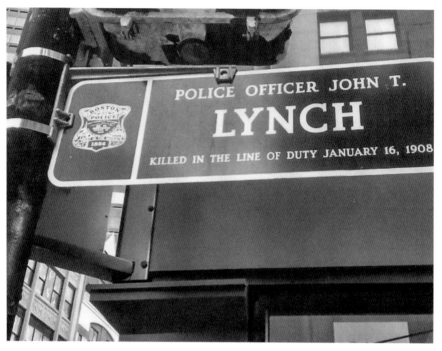

Officer Lynch memorial marker, at the corner of Boston's Kingston and Summer Streets, where he was mortally wounded. *Photo by Winnie H. Liang.*

On June 9, 1908, Arthur Smith, the man who had gunned down Lynch, was convicted of first-degree murder. The judge showed a degree of mercy by sentencing him to life imprisonment, igniting outrage among the public and the police force. Smith was paroled in 1942.

Today, a memorial marker honors Patrolman Lynch at the junction of Summer and Kingston Streets, the site where he was shot. Passersby should stop for a moment and take a look at the simple plaque. It commemorates a man who embodied the motto "To serve and protect."

4

ON THE PICKET LINE

The Boston Police Strike of 1919

A t 5:45 p.m. on September 9, 1919, as the Tuesday evening shift of the Boston Police began, 1,117 of the city's 1,544 officers walked off the job. Nearly three-fourths of the department had gone on strike, most of them with Irish roots. To the horror of many Bostonians, the streets belonged to criminals for the moment.

That the Irishmen on the force had a long list of justifiable grievances and had sought to negotiate them meant little to Police Commissioner Edwin Upton Curtis. When the men in blue appealed for a modest increase in pay, they might as well have tried to squeeze blood from the proverbial rock.

Of equal concern to the financially strapped officers were their overly long shifts, which included grueling special details and a night in the station house every week, and the condition of those quarters. Rotting floorboards, cots infested with cockroaches and lice, crumbling plaster—these torments awaited the officers each day and night.

Founded by officers in 1906, the Boston Social Club had been the force's grievance outlet. As word spread that the police intended to form a union, Massachusetts governor Calvin Coolidge reaffirmed his publicly stated opposition to and unwillingness to deal with any such "Local." Four days before the police officially organized on August 9, 1919, for a union under an AFL (American Federation of Labor) charter, Curtis had amended Rule 35 of the department's Rules and Regulations to ban any police organization from aligning itself with any outside group except veterans' organizations. Bostonians waited to see if the police would back down and obey Curtis's edict.

The officers stuck together. Curtis responded on August 26 and 29 by putting nineteen officers on trial for disobeying his amendment. On September 8, 1919, the nineteen men were convicted of union activities, and their suspensions were extended. Within a few hours of the verdict, the Boston Police voted 1,134 to 4 in favor of a strike. They walked off the job late the following afternoon.

By 8:00 p.m., unruly crowds had gathered in downtown Boston. Suddenly, several miscreants broke into a tobacco store and ransacked it. As if on cue, mobs tore up and down Hanover and Washington Streets, looting, brawling and terrorizing people. The upheaval soon spread to South Boston.

The undermanned police—72 percent of the 1,544-man force refused to report for work—could not contain the violence, and by daybreak, shattered windows, looted stores and scores of battered citizens led Governor Coolidge to call out the Massachusetts State Guard. Commissioner Curtis mobilized his "volunteer police force," condemned as scabs by the striking officers,

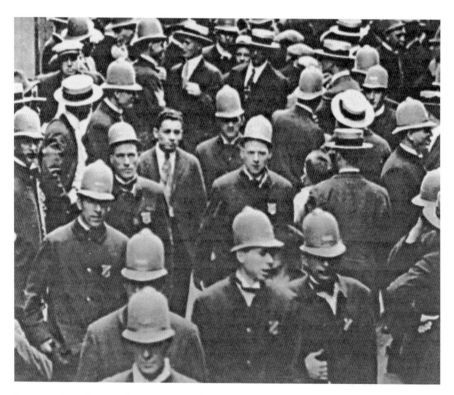

Boston Police officers going on strike on September 9, 1919. *Courtesy of Boston Public Library* (Boston Post *Archive).*

whose pleas for redress had been ignored and now condemned by the city and state governments.

On Wednesday, the mobs returned, battling with the volunteers, but as the guard was deployed in force that evening, some semblance of order returned. Although violence continued for several more days, gunfire breaking out in downtown Boston, by the weekend, the troops had taken back the streets.

To the collective fury of Bostonians and especially Yankees who loathed the Irish, eight people had been killed—five by guardsmen—and many others wounded; property damage was extensive.

Despite the anger of many toward the striking policemen, city and state officials feared that Boston's other unions would walk off their jobs in support of the officers, crippling transportation and other services. That scenario never developed. The police stood alone.

Some of the strikers began to waver, and feelers about a compromise went out to Curtis and Coolidge. AFL president Samuel Gompers sent

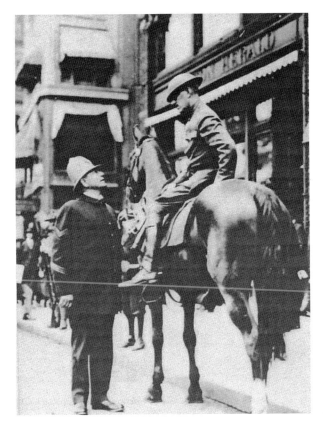

Striking Boston Police officer and mounted soldier in animated conversation. *Courtesy of Boston Public Library*.

Governor Coolidge a telegram requesting that the police be reinstated and their concerns be addressed later. "Silent Cal" responded with words that, in large part, would carry him to the White House: "There is no right to strike against the public safety by anybody, anywhere, anytime."

With the Massachusetts State Guard still patrolling the streets, Curtis filled out the ranks of his new police force, adding many more "real Americans."

"Good American Yankees do not strike" was the sentiment of letters imploring Curtis to shave Irishmen from the force. He was only too happy to swing with the anti-Irish tide.

None of the officers who walked from their stations on September 9, 1919, got their jobs back. Most were Irish. The bitterness of the fired policemen and their families endures among their descendants to the present day. While the issue of public safety was—and still is—debated, many in the community long viewed the Boston Police Strike as Yankees versus Irish.

On two facts, historians largely seem to agree: the heavily Irish police force did have legitimate grievances; however, the walkout did result in a crime spree on Boston's streets, posing a genuine threat to public safety.

Still, one can only speculate what might have happened if Curtis and company had responded earlier and more sympathetically to the men in blue's legitimate concerns. The strike remains a controversial chapter in the history of Boston, labor and America.

Part II

OF BRUSH, CHISEL AND BATON

5

"A PROPER BOSTONIAN" IRISHMAN

John Singleton Copley

O ne of Boston's most famous and scenic sites bears his name. He is renowned as the portrait painter who rendered the literal face of the American Revolution. Paul Revere, Sam Adams, Dr. Joseph Warren—those prominent Bostonians and Patriots and other Rebels sat for the talented painter. At that time, to the artist, they were his neighbors. He painted their images before the "shot heard round the world" ignited the Revolution. By April 1775, John Singleton Copley was long gone and on his way to earning acclaim as one of the age's greatest painters—in London. A Tory—loyal to the Crown—he would never return to his native Boston.

John Singleton Copley was born in Boston in 1737 or 1738—the date is uncertain—to Irish parents, the son of Richard Copley of County Limerick and Mary Singleton of County Clare, who had immigrated to Boston in 1736. Richard, reeling from myriad health problems, soon traveled to the warmer clime of the West Indies in hope of regaining his strength, but he died there in the year of his son's birth. Again, the accuracy of the date is not definitive, as some historians believe the elder Copley died in 1737 and others evince the year as 1738.

Mary, in the unenviable position of being a young widow in an unfamiliar land and running her deceased husband's tobacco store on Boston's Long Wharf, was remarried in 1748 to Peter Pelham, a well-known Boston engraver, with whom she had a son, Henry.

From an early age, John Singleton Copley displayed a God-given talent for drawing and, according to historian James B. Cullen, "developed it,

uninstructed, without models or assistance, either in drawing or coloring. He had native genius, industry, and taste."

Brimming with artistic ambition, Copley sent a painting of his half brother, Henry, in 1760 to one of the era's foremost artists, Benjamin West, in hope that the work might be considered for the prestigious Royal Academy in London. The painting, *The Boy and the Flying Squirrel*, captivated West, who replied with a letter praising Copley's "superb" gift "in coloring, as well as artistic in design and drawing." West encouraged the young painter to travel to England, live in West's home and develop his talent. The offer "strongly tempted the young artist," Cullen writes, "but he resolved to remain with his mother, and assist her to maintain the family."

Demand for Copley to paint "everyone who was anyone" in Boston brought him success in his own right and in 1769 helped win him the hand of Susannah Farnham Clarke, whose father was one of the wealthiest merchants in the colonies. Copley's father-in-law was the agent for the East India Company and would sign the manifest for the tea that Sam Adams and fellow Sons of Liberty would toss into Boston Harbor in the Boston Tea Party.

The newlyweds moved into a Beacon Hill mansion with seven acres, and from there Copley's fame and success spread throughout the thirteen colonies as his skilled hand immortalized the luminaries of the day. During a trip to New York City in 1771, he painted a miniature portrait of a Virginia planter named George Washington.

His mother and his family now well provided for, Copley set sail for London in June 1774 to pursue his dream of studying the work of Europe's master painters. His travels led him from London to Rome.

While Copley was in Europe, word that rebellion had exploded in Boston reached him. A staunch British Loyalist, Copley hastily booked passage from Boston to England for his family on the *Minerva*, the last passenger vessel to depart Boston as a British colony. Perhaps fittingly or even ironically, the ship's master bore the Hibernian surname Callahan.

By the time of Copley's death on September 9, 1815, he had fallen into deep debt. He was recognized as a great painter, but a soul- and cash-crushing combination of a royal lifestyle, commissions for which he was never paid or was short-changed, stress, depression and, ultimately, declining health ruined him.

Still, John Singleton Copley is remembered as the first great artist to emerge from the thirteen colonies. In Boston, Copley Square bestows a local brand of immortality on the Tory who painted Boston's Rebels.

6

"THE MAGNIFICENT MILMORE"

Martin Milmore's Monumental Mark

W hen it comes to the Boston Common and the Public Garden, images of "Proper Boston" resonate with Brahmin gentility. From the graceful swans and brilliant flowers and shrubbery of the Public Garden to the tree-shrouded paths and impressive statues and monuments of the Common, one can conjure visions of well-tailored nineteenth-century men and women strolling arm in arm along both sites. Somehow, one might think that the proverbial "footsteps of the Gael" arrived late on the two venerable Boston tracts. However, along with Irish-born William Doogue, who left his literal imprint on the sites as the superintendent of common and public grounds in Boston from 1878 to 1906, a gifted sculptor from the old sod crafted one of the Common's most famous landmarks, the Soldiers and Sailors Monument.

The magnificent memorial, dedicated in 1877, is the work of Martin Milmore. Born in County Sligo, Ireland, on September 14, 1844, Milmore was the son of a Protestant schoolmaster. Surviving the horrors of the Great Famine, he immigrated to Boston with the family in 1851. Milmore's elder brother, Joseph, born in Sligo on October 22, 1842, would pave the way for Martin's own career.

After attending Boston's Brimmer and Quincy Schools, Joseph was apprenticed to a cabinetmaker, his path to a decent profession seemingly assured. He was less than enthralled, though, with woodworking and left the employer to learn the craft of marble cutting. He not only loved his new field, but he also showed a rare gift for shaping architectural marble and stone.

Martin graduated from the Boston Latin School in 1860 and chose to follow Joseph's lead by first taking wood-carving lessons from his brother and then by earning an apprenticeship with the well-known Charlestown sculptor Thomas Ball. Although Boston seethed with anti-Irish prejudice, that bias was directed against Irish Catholics. The Milmores' middle-class Irish Protestant roots made life easier in the city and opened up educational and career opportunities denied to most Catholic immigrants.

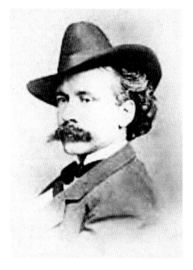

Martin Milmore, an Irish immigrant to Boston who became one of America's most famed and gifted sculptors. *Library of Congress.*

In Ball's studio, Martin Milmore soon proved the student whose talents exceeded the teacher's abilities. Milmore's "modern sculpture was a bust of himself which he shaped with the aid of a large mirror." Those who knew him well were not surprised that his first effort at sculpting was to model a bust of himself with the help of a mirror: "In terms of vanity, the budding young sculptor was undeniably pleased with himself."

Determined to make his own way as a sculptor and confident in his ability to do so, Milmore opened his own studio in his early twenties. In 1864, he was commissioned to sculpt classical statues of Ceres, Flora and Pomona to grace the entrance of the Old Horticulture Hall on Tremont Street. As people scrutinized his deft handiwork, patrons and commissions began to flow to his studio. His statuette *Devotion* was created for Boston's Sanitary Fair in 1863, and in 1867, he was awarded the contract to design the Roxbury Soldiers Monument at Forest Hills Cemetery in Jamaica Plain, a harbinger of another work, one that would make him famous.

Although there was no lack of gifted sculptors in Boston and elsewhere, Milmore won the city's contract for a monument to be raised on the Common to pay tribute to the Union soldiers and sailors, a project that could make or break his reputation.

Milmore traveled to Rome and lived there for a time to study the works of ancient and Renaissance master sculptors. He began planning and sketching themes and actual parts of the Civil War memorial and found time to sculpt busts of the high and mighty who made their way

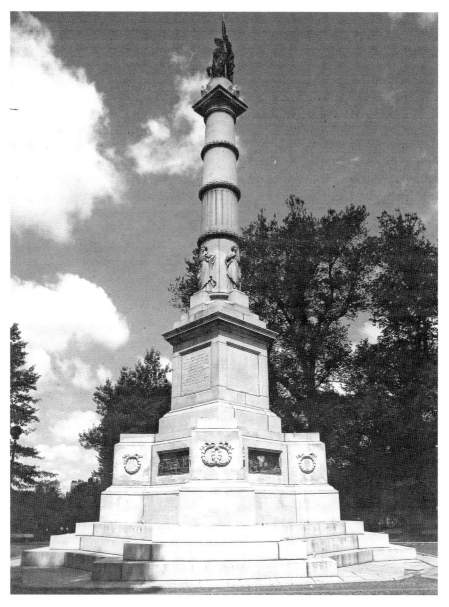

Martin Milmore's world-famous Civil War Soldiers and Sailors Monument, on Boston Common. *Photo by Peter F. Stevens.*

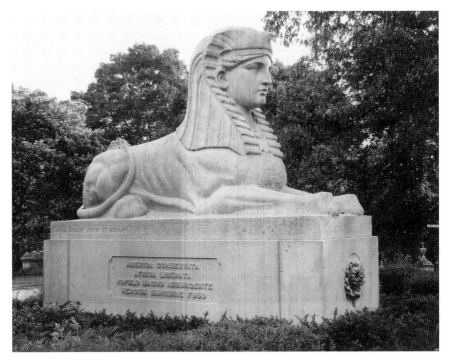

Mount Auburn Cemetery sphinx, in Cambridge, Massachusetts, honoring the Union's Civil War dead, was sculpted by Milmore and his brother, Joseph. *Photo by Peter F. Stevens.*

to his Rome studio, the roster including such Massachusetts notables as Charles Sumner, Wendell Phillips and Ralph Waldo Emerson. Milmore also rendered a bust of Pope Pius IX.

In 1877, Boston newspapers proclaimed the news that Milmore's much-anticipated monument was ready to be dedicated on the Common. A throng of art lovers and twenty-five thousand Civil War veterans gathered for the event. The occasion was one of great pride for the veterans, and as the Boston Art Commission noted, "Peter Nolan of Post 75, Grand Army of the Republic, marched the entire route on crutches, having lost a leg at the second battle of Bull Run."

What the crowd saw when the memorial was unveiled was a granite shaft surmounted by a bronze figure of "Liberty." Fittingly, the pedestal was flanked by statues that represented "Peace, the Sailor, the Muse of History, and the Soldier." Four brilliantly rendered bas-reliefs were placed between the projections on which the statues stood, the quartet of reliefs capturing the "Siege of Fort Sumter," the "Departure of the Forces for the War," the work of the Boston Sanitary Commissions and the "Return from the War."

In the words of fellow sculptor Daniel Chester French, there was no mistaking the man who had designed the monument: "Milmore was a picturesque figure, somewhat of the Edwin Booth type. With long dark hair, and large dark eyes, he affected the artistic…wearing a broad-brimmed soft black hat, and a cloak. His appearance was striking, and he knew it."

Milmore continued to fashion sculptures, from busts to full-fledged monuments. Among the subjects of his famous "portrait busts" were Ulysses S. Grant, Abraham Lincoln and New York's Cardinal John McCloskey. Among Milmore's later works on a grander scale were his statue of General Sylvanus Thayer at the U.S. Military Academy, the granite sphinx he created with his brother Joseph for Mount Auburn Cemetery in Cambridge, his statue of *America* in Fitchburg and his *Weeping Lion* in Waterville, Maine. Milmore's final work was a bust of Daniel Webster for the New Hampshire State House, in Concord.

Martin Milmore, just thirty-eight years old, died in Boston on July 21, 1883; his brother, Joseph, died in Geneva, Switzerland, in 1886. After the latter's passing, the Milmore family requested that Daniel Chester French design a memorial to the deceased brothers, and in their memory he crafted a memorial named *Death and the Sculptor* in Forest Hills Cemetery in Jamaica Plain.

Today on Boston Common, the Soldiers and Sailors Monument stands in tribute to those who served to save the Union. The memorial also pays tribute to the genius of a man who began his life in County Sligo and rose to become one of the foremost sculptors of his era.

7

THE MUSIC MAN

Maestro Patrick Gilmore

he Father of the American Band," "America's Greatest Bandleader,"
"The Man Who Invented the Band"—all of these plaudits, one
might think, refer to John Philip Sousa. One would be wrong. As
noted by Gilmore historian Michael Cummings, they sing the proverbial
praises of Patrick Sarsfield Gilmore, an Irish immigrant who topped the
concert circuit of the nineteenth century.

Much of what is known about Gilmore has come about through the efforts
of researcher and collector Michael Cummings and author Michael Quinlin.
Cummings founded the Patrick S. Gilmore Society in 1969 and spent years
amassing materials related to the renowned nineteenth-century bandleader.
Cummings's labors to keep alive the name and music of the Irish-born
conductor fueled the well-received annual Gilmore memorial concerts on
the Boston Esplanade from 1993 to 2002. Cummings donated his collection
to the Irish Music Collection at the John J. Burns Library, Boston College.
Today, Quinlin's Boston Irish Tourism Association updates and maintains
the society's website, which is a tremendous source for researchers, historians
and anyone interested in the bandleader and his colorful life and music, as is
Quinlin's book *Irish Boston*.

On Christmas Day 1829, Patrick Stephen Gilmore was born in Ballygar,
County Galway. Gilmore displayed innate musical ability from his early
years, learning to play the fiddle, the fife and the drum. After hearing a
British army band perform in Athlone, young Gilmore announced to his
family that he wanted to join the army musicians. His shocked father—an

avowed Irish nationalist—forbid him to do so and quickly apprenticed him to an Athlone liquor-seller named Fallon.

Gilmore learned every aspect of the liquor trade, but his commitment to music and a career in it never waned. During his off-hours, he studied the notoriously tricky B-flat cornet and joined the popular Keating Band. As a member of the choir at St. Peter's Church Choir of Athlone, he absorbed the ins and outs of choral arrangements.

Old enough to determine his own course, chafing at the prospect of being a grocer or liquor-seller, he joined the British army in "Black '47," the worst year of the Great Famine, and was shipped to Canada as a "bandsman." The next two years of his life remain cloudy for historians. Several accounts surmise that, as a bandsman, he was technically a civilian, not a soldier and able to leave his posting. In 1848 or 1849, he arrived in Boston.

Gilmore soon landed a job with the band department of Ordway Brothers Music Store, where he formed a group called the Ordway Eolians, which became a favorite of P.T. Barnum. In the sort of break that every musician or singer dreams of, Barnum hired Gilmore and his group to perform as the band for the world's most famous singer, Jenny Lind, the "Swedish Nightingale."

His reputation burgeoning, Gilmore first was appointed leader of the popular Boston group the Charlestown Band and next of the Boston Brigade Band. Foreshadowing the later Boston Pops concerts, Gilmore presented Fourth of July concerts on Boston Common and gave recitals at the Boston Music Hall.

Not everything was going Gilmore's way in Boston, despite his fast rise on the music scene. Because of pressure from anti-Irish Americans—"Know-Nothings"—he changed his name from the Catholic-sounding Patrick Stephen Gilmore to Patrick Sarsfield Gilmore. The bigots did not realize that Sarsfield, a legendary seventeenth-century Irish general, had been a famous symbol of Irish rebellion against the Crown.

In 1857, the immigrant formed Gilmore's Band, which featured two woodwinds to each brass instrument—the same combination used in modern concert bands, as Michael Cummings notes. Gilmore did his bit during the Civil War, his band serving with the Massachusetts Twenty-Fourth Regiment. He composed such band classics as "When Johnny Comes Marching Home," "Good News from Home," "We Are Coming, Father Abraham," "Seeing Nellie Home" and other immensely popular tunes.

One of Gilmore's crowning achievements came in Boston in 1872, when he organized and led the World's Peace Jubilee, leading a two-thousand-piece orchestra and a twenty-thousand-voice chorus in a specially built

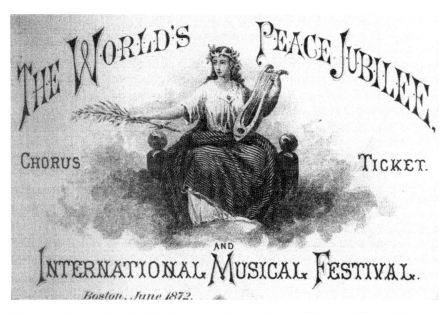

Ticket to Gilmore's famed Jubilee Concert in Boston. *Courtesy of Cummings Gilmore Collection, Burns Library, Boston College.*

coliseum that held over thirty thousand concertgoers. The guest star was world-renowned composer Johann Strauss Jr., son of the immortal Johann Strauss. Strauss Jr. was paid the astronomical sum of $100,000 to appear at these concerts, the event proving to be the only time he visited America.

The bandleader went on to design Gilmore's Concert Garden, which later earned fame as the first Madison Square Garden. Throughout the late nineteenth century, he served as the musical director for the nation's most celebrated events, such as the 1876 Philadelphia Fourth of July centennial and the dedication of the Statue of Liberty in 1886. He and his band were the headliners at the Manhattan Beach Hotel and at the St. Louis Exposition. In 1878, the Gilmore Band's tour of Europe was a smash success, and his annual concert tour of the United States filled huge venues year in and year out.

Standing on the cutting edge of technology, Gilmore made several of the first commercial phonograph recordings for Thomas Edison in 1891. A tradition created by Gilmore is still going strong today—ringing in the New Year in Times Square, New York.

Patrick Stephen Sarsfield Gilmore died in 1892. The sweeping saga that was the bandleader's life remains a remarkable chapter in the annals of the Boston Irish and Irish America.

Part III

AROUND THE DIAMOND AND THE TRACK

THE MYSTERIOUS MARATHON MAN

John McDermott

In 1897, the very first Boston Marathon had a decidedly "green" hue—the first winner of the race was a man named John J. McDermott. He ran for the Pastime Athletic Club of New York City, and while he has been hailed in most quarters as an Irish American and certainly did possess Celtic bloodlines, he remains something of an enigma.

Nova Scotia claims him as a native who may have been either Irish or Scottish or both, a Cape Breton newspaper recently stating that "John McDermott (or perhaps known as John J. MacDermid) was born in Ireland or Scotland or Cape Breton, Canada, between 1868 and 1871."

Despite this little "Marathon Mystery," it is indisputable that the first winner of the grand Boston race was a runner named McDermott. He also provided one of the all-time great post-marathon quotes. After dropping nine pounds during his victory, he told a *Boston Globe* reporter, "This will probably be my last long race…look at my feet."

McDermott, the pain of his triumph faded or a now-distant memory, came back to run the Boston Marathon in 1898, finishing fourth. He never competed in the contest again and dropped off of history's stage. Fleet of foot, his turn on the marathon stage proved equally fleeting.

The spirit that drove McDermott and his fellow runners to the Boston course in 1897 is one that dates back to marathons then and now. According to Greek historical legend, a soldier named Pheidippides (also spelled Phidippides) was dispatched from the plains of Marathon to Athens to carry the news of the vastly outnumbered Greeks' triumph

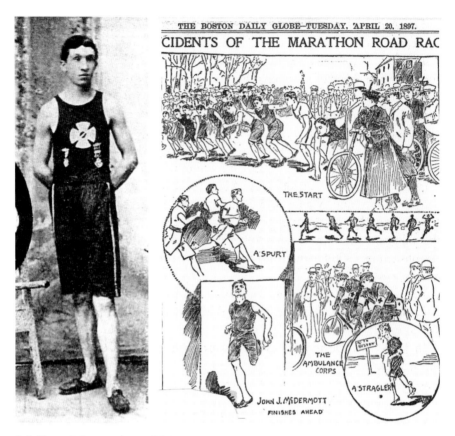

THE BOSTON DAILY GLOBE—TUESDAY, APRIL 20, 1897.

CIDENTS OF THE MARATHON ROAD RAC

THE START

A SPURT

THE AMBULANCE CORPS

A STRAGLER

JOHN J. McDERMOTT FINISHES AHEAD

Left: The only known photo of John J. McDermott, winner of the first Boston Marathon, 1897. *Courtesy of Boston Public Library (*Boston Post *Archive).*

Right: Illustrated newspaper account of the 1897 Boston Marathon. Boston Post.

over the Persian army. After running 24.8 miles, he staggered into Athens and, an instant before collapsing, announced the news from the Marathon battlefield: "Rejoice! We conquer!"

Following the 1896 Paris Olympics—the first since the days of ancient Greece—Boston Athletic Association (BAA) members and U.S. Olympics team manager John Graham were so caught up by the majesty of the Olympic Marathon that they wanted to bring that experience to all of Boston. Graham convinced affluent local businessman Herbert H. Holton to help him create and launch a Boston Marathon, the two men mulling a number of routes.

On April 19, 1897, the inaugural Boston Marathon unfolded from Metcalf's Mill, in Ashland, to the Irvington Oval. The route stretched 24.5 miles, not yet the classic distance of 26.2 miles. John J. McDermott crossed the finish line ahead of fourteen other runners to win the first BAA Marathon with a time of 2:55:10, cementing his place forever in the marathon's annals. As Red Sox fans would later learn all too well, it was not to be the only time an athlete from New York rained on Boston's proverbial sports parade.

The Big Apple can do nothing to eclipse a uniquely Boston take on the marathon. Beginning in 1897 and continuing through 1968, the race was always held on Patriots Day, April 19, a holiday recognized only in Massachusetts and Maine and honoring the outbreak of the American Revolution. Only if the nineteenth was on a Sunday was the race run on the following Monday. When the Patriots Day holiday was legislatively established in 1968 for the third Monday in April, Marathon Monday was officially established.

For every marathoner who conquers "Heartbreak Hill" and crosses the finish line, in Copley Square, the words of Pheidippides endure: "Rejoice! We conquer!"

In John J. McDermott's case, the words are slightly different: "Rejoice! We *disappear.…*"

9
PATSY AND THE BAMBINO

Patrick Donovan

A mong the many Red Sox managers with ancestry from the old sod, only one literally hailed from the Emerald Isle. His name was Patrick Joseph "Patsy" Donovan.

Donovan managed the Sox for only two seasons, 1910–11, after a splendid playing career that still has many baseball buffs pushing him to the Veteran's Committee as a "Deadball Era" star worthy of enshrinement in Cooperstown. He compiled a mediocre 159-147 record at the team's helm and an overall .438 winning percentage, including managerial stops in Pittsburgh, St. Louis, Washington and Brooklyn—hardly Hall of Fame stuff. As a scout, though, he had few peers, with one sportswriter lauding him as an "excellent Judge of the ball player in the raw." It's hard to argue with that compliment. Because of Patsy Donovan, Babe Ruth and future Hall of Fame pitcher Ernie Shore ended up playing on the Fenway diamond.

Born in Queenstown, Country Cork, on March 16, 1865, Patsy was the second of Jeremiah and Nora Donovan's seven children. He was three when his family immigrated to Lawrence, Massachusetts. As with many of the Irish children there, to help his family survive, he went to work right from elementary school to the hardscrabble city's cotton mills. Young Patsy, however, had one chance to escape a life of endless hours and scanty wages in the mills. On the baseball field, he was a fleet-footed outfielder, base-stealer and hitter who first grabbed scouts' attention in 1886 when he starred with the Lawrence club in the professional New England League.

Standing five feet, eleven inches and weighing 175 pounds in his prime, left-handed at the plate and in the field, Donovan was not a slugger, even by Deadball Era standards, but his abilities as a slap-hitter proved prodigious. So, too, did his strong, accurate arm and his base-swiping (518 stolen bases by his career's end).

To the delight of his family and friends in Lawrence, his big-league debut came in 1890 with the National League's Boston Bean Eaters. His first stint in the Hub ended quickly when he was moved halfway through the season to the powerhouse Brooklyn Bridegrooms, who went on to win it all, the only time he ever played for a championship team.

After stints with the Louisville Colonels and the Washington Statesmen (they became the Senators when he was there), he landed with the Pittsburgh Pirates, batting .300 or better for the next six years and doing double duty as the team's player-manager in 1897 and 1899, earning the label "most successful Irish-born major leaguer" by the turn of the twentieth century.

Shipped to St. Louis, he led the league with forty-five stolen bases in the 1900 season and served as player-manager from 1901 to 1903. The baseball writer David Jones notes, "In a decade that was infamous for rough play and rowdyism, Donovan was most admired for his quiet dignity and work ethic."

Leading the Cardinals to a surprising 76-64 record in 1901, hopes were high for the next year as Donovan won high marks for "treating his players honestly and fairly." Then, all of the team's best players—except Donovan—jumped to the new American League, signing with the crosstown Browns. Gutted by the defections, the Cardinals fell apart. In 1903, the team finished 43-94, 46½ games out of first place, and Donovan was jettisoned by the front office. Since he was pulling down an $8,000 salary that made him the game's highest-paid player, the bosses found it an easy decision to make.

Donovan's career was winding down. His last full season on the diamond was in 1904, as player-manager with the Senators. Over seventeen major-league seasons, Donovan racked up 2,246 hits, 3,318 runs and 736 RBI in 1,821 games, with 207 doubles and 75 triples. He hit but 16 homers but stole 518 bases and had a career batting average of .313. He was also one of the best right fielders of his day, gunning down 30 baserunners in 1902 and racking up 264 career assists.

After disastrous managing stops in Washington and Brooklyn with subpar players, the hard-nosed, competitive Patsy yearned for "the opportunity

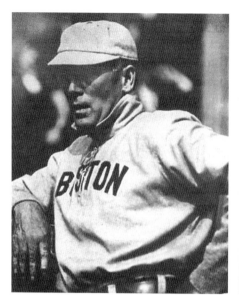

Left: Patrick "Patsy" Donovan during his stint as manager of the Boston Red Sox. *Courtesy of Boston Public Library (*Boston Post *Archive).*

Right: Patrick "Patsy" Donovan, the greatest Irish-born baseball player in the game's annals. *Courtesy of Boston Public Library (*Boston Post *Archive).*

of handling a club where I would have free rein and financial backing to secure talent."

He would get his chance with the Red Sox. After taking a job as a Boston scout in 1909, he was hired to manage the team in 1910 and 1911; success was minimal with that 159-147 record.

Although he was replaced by Jake Stahl in 1911, the front office respected Donovan both as a man and as a judge of talent and asked him to stay on as a scout. He agreed, having come to consider Boston his hometown. In 1910, he married another Lawrence native, Tresa Mahoney, with whom he had three sons and a daughter. His decision was one that would help bring Babe Ruth to the Sox.

In 1914, Donovan the scout was dazzled by the pitching and batting talents of Ruth, who was playing for the minor-league Baltimore Orioles. Drawing on his friendship with a Xaverian Brother who had coached Ruth at St. Mary's Industrial School for Boys, Patsy persuaded Ruth that Boston would be a good fit for him, and he then persuaded Sox owner Joseph Lannin to sign Ruth "at any price." David Jones writes: "Donovan never claimed to have discovered Ruth—the young lefthander was too talented for

his exploits to go unnoticed." Donovan, however, was the man who brought the Babe to Boston.

In a baseball career that spanned sixty-four years, Donovan went on to manage several minor-league teams and coached at Andover's Phillips Academy, where he honed the talents of a slick-fielding first baseman named George Herbert Walker Bush. Donovan died on Christmas Day in 1953 at the age of eighty-eight (ninety, according to various sources claiming that he fudged his age as he started his playing career) in Lawrence and was buried there in St. Mary's Cemetery.

Former president George H.W. Bush supported a push to try to get his old coach into the Hall of Fame in 2001, writing of his admiration for "Patrick Donovan…a man of the highest character."

Donovan still hasn't made it into Cooperstown, even though he was one of the game's best players at the turn of the century. He would likely have enjoyed the fact that in the Irish Baseball League, the highest prize is "The Patsy Donovan Batting Champion Award."

Part IV

BOYOS, A BALLOT BUSTER AND A BREAKFAST TRADITION SHATTERED

STORMING THE BALLOT BOX

The Boss of the City and Hugh

P atrick J. Maguire engineered a momentous and long-running feat in nineteenth-century Yankee Boston. For the first time in the city's annals, he clawed a political foothold for the Irish on the city's anti-immigrant, anti-Catholic political turf.

No one could have predicted that Maguire's path was to lead to ballot-box clout for his fellow Irish amid "the Anglo-Saxon icicles of Yankee Boston." He was born on March 14, 1840, in County Fermanagh, Ireland, and arrived in Boston at the age of five with his family in the very years that the Great Famine, *An Gorta Mor*, struck Ireland. Growing up in the waterfront tenements, "rookeries," of the city's North End, Maguire proved a gifted student in Boston's public schools and also gifted with quick fists, which he used against Protestant classmates. They soon learned to leave him alone.

He left school in his teens to help earn money for his family, apprenticing to learn the tailor's trade at the firm of Lothrop & Godfrey. After a stint as the foreman at the Oak Hall Clothing House, he took a position with clothier George J. Jacobs. The young Irishman's skills in turning out stylish suits not only boosted the store's profits but also led Jacobs to go into a partnership with him. Determined to run the proverbial show, Maguire eventually launched a clothing firm with a fellow Irishman named Sullivan. The company of Sullivan & Maguire landed the business of many of Boston's blueblood Brahmin movers and shakers.

Patrick Maguire was a man on the rise, and with financial success he became determined to help the city's Irish immigrants find not only stable

jobs but also the one thing that would tear down the daily prejudice that the Boston Irish faced: political power. He ran for and won a seat on the Boston Common Council from 1879 to 1884, the first Irish-born local to do so. From there, he earned the powerful post of Director of Public Institutions from 1882 to 1883; over the objections of many entrenched Protestant leaders, he persuaded the mayor and governor to allow Catholic priests to say Mass for the inmates at Boston's main prison, Deer Island. He also instituted a program to teach inmates the clothing trade, and the construction of a hospital there.

As Maguire became one of the city's first Irish power players, he founded a newspaper titled the *Republic* to serve as the chief political platform for his crusade to wrest clout from the Yankee establishment. He looked in Boston's Irish wards for men who had the smarts and toughness to run for office with his help and his financial support. One of his handpicked protégés was Hugh O'Brien. Under Maguire's tutelage, O'Brien had served for seven years as an alderman, the first Irishman to hold the position in Boston.

By 1883, Maguire had decided that it was high time that Boston elect an Irish mayor and that Hugh O'Brien was just the man for the job. Maguire dispatched his ward bosses to knock on every household's door in the North End and West End and try to persuade every eligible Irishman to vote for O'Brien. In the weeks before voters hit the polls, many Yankees recoiled against the notion of an Irish-born mayor, even though the man's financial

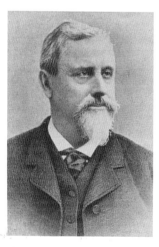

and business outlook had more in common with his Protestant and Republican foe, Augustus Mann, than with fellow immigrants. Although the Irish turned out in force for their candidate on Election Day, O'Brien lost the race by a narrow margin. Maguire believed a second O'Brien run would prove different.

Hugh O'Brien, along with Maguire, was not only of Boston, but also of Ireland itself. To many Yankees and Brahmins, his ascent represented a once unthinkable development in a region notable for its antipathy toward Irish Catholics.

Both O'Brien and Maguire shared a great deal in their lives' courses. O'Brien's odyssey to the top of the heap in Boston politics began in 1832, when his parents emigrated from

Hugh O'Brien, an Irish immigrant who, in 1884, became Boston's first Irish mayor. *Courtesy of the* Boston Pilot.

Ireland to Boston with their five-year-old son. He displayed a considerable intelligence early on, but he was yanked from the city's public school system as a twelve-year-old to work as an apprentice to a printer for the *Boston Courier*. A tradesman's future beckoned the youth, lucky that he could escape the low-paying and insecure street-sweeping or dockside work so many of his fellow Irish immigrants were forced to take. Young O'Brien, however, set his eyes on a far loftier future, one amid the rarefied circles of Yankee commerce.

Following his stint at the *Courier*, O'Brien took a slot at the private printing firm of Tuttle, Dennett and Chisholm on School Street, learning the ins and outs not only of printing but also of publishing his own paper, the *Shipping and Commercial List*. His publication proved a smash among Yankee merchants and Brahmin financiers who depended in any way on the flow of goods and business news across Boston's docks. The Irish Catholic had garnered quite a feat in making himself indispensable to well-heeled Protestants whose Back Bay and Beacon Hill brownstones generally meant only one thing to immigrants of "the old sod": backbreaking work as maids or handymen. Brahmins looked grudgingly at O'Brien in a different light. Many upscale sorts began to view him as an anomaly—one of the "good Irish."

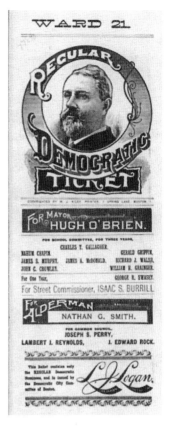

Mayoral campaign flyer for Hugh O'Brien, landmark Boston Irish politician. *Courtesy of Boston Public Library.*

O'Brien's business value to New England merchants and moguls notwithstanding, the question of how far the ambitious publisher could rise in Brahmin Boston intrigued Maguire and his Democratic ward bosses, who ruled the city's Irish neighborhoods. In 1875, the forty-nine-year-old O'Brien won election to Boston's Board of Aldermen, and the watchful eye of Maguire and the Irish community noticed when, over the next seven years, even hard-boiled Yankees lauded his "conscientious hard work." O'Brien ran for mayor and lost, but the political door was coming ajar.

In 1884, Maguire orchestrated O'Brien's second campaign for mayor. This time, enough Yankee voters swallowed misgivings about an Irish-born candidate and helped the immigrant poor sweep him into office. The Irishman captured fifteen of Boston's twenty-five wards. His campaign platform of lower taxes and his demonstrated ability as an alderman to back that promise had proven a fiscal siren song too sweet to resist for many Brahmins.

Hugh O'Brien was sworn in as the city's first Irish-born mayor on January 5, 1885, heralding a new political era for Boston and for the region. He wasted little time in keeping his campaign promises of sound spending and lower taxes, worked to improve the city's parks and roads and helped to lay the groundwork of the Boston Public Library, a site where even "Paddy and Bridget" would be allowed to read and study. O'Brien would hold the office until 1889, winning reelection. He set the political stage for 1903, when Patrick Collins, a resident of Dorchester, won the Boston mayoral race. The era of Irish domination in Boston politics had arrived, due in large measure to "the Boss," Patrick J. Maguire.

MADAM CHAIRMAN

"No Guff" Duff

In the early twentieth century, Julia Harrington Duff, of Charlestown, Massachusetts, claimed a piece of Boston political and educational turf where no woman had stood. She won election to the city's school committee and became the board's first Irish American female member—before America's women had even won the right to vote.

Born in 1859, Duff taught for fourteen years in Boston before her marriage to Dr. John Duff. They settled in Charlestown to raise a family. With her election in 1900, she would soon prove a potent force on the school committee, her Irish background fueling her vociferous and dogged battle against what she deemed "Protestant reforms" of the Public School Association (PSA). Her "us-against-them-approach"—"us," in her view, were Irish Catholics—typified the ongoing polarization between "the neighborhoods and Yankee nobs" of the era. Her crusade for "Boston schools for Boston girls" contended that Protestant teachers who did not live in Boston were hired over young Catholic women from Boston's Normal School (for teachers).

Extending her role as teacher and mother, she became an ethnic spokesperson as she confronted the power of the Yankee Protestant men of the Public School Association. She worked to replace thirty-seven-year-old textbooks, always continuing her push to protect the claims of local Boston women for career opportunities in the school system and to propose a degree-granting teachers college.

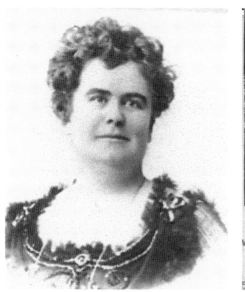
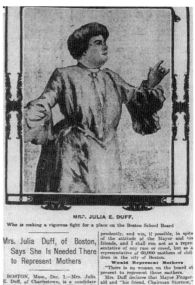

Left: At the turn of the twentieth century, former teacher and school-committee trailblazer Julia Harrington Duff transformed Boston's schools. Boston Post.

Right: Illustrated Boston newspaper feature on landmark educator Julia Harrington Duff. Boston Post.

Polly Welts Kaufman, in "Julia Harrington Duff: An Irish Woman Confronts the Boston Power Structure, 1900–1905," writes that Duff "championed the cause of the Irish-American women who wanted to be Boston Public School teachers.

"Although she was a graduate of Boston Normal School and a former teacher in the Boston public schools, her election was rather unexpected. It was unexpected, that is, by the *Woman's Journal*, the organ of the American Woman Suffrage Association published in Boston, because Duff was unknown to them. A few days before the election, the *Journal* editors, who earlier had warmly endorsed the two other women candidates, noted that the Democrats had nominated a woman and weakly said they 'would be glad to see all three of the ladies elected.'"

By the time of her death, in 1932, Julia Harrington Duff had opened up opportunities for fairness in Boston's hiring practices for Irish American women. As Kaufman notes, "The election of Julia Duff to the Boston School Committee was the culmination of the political awakening of young Irish-American teachers and working women in turn-of-the-century Boston."

BREAKING A BOYOS'
BREAKFAST TRADITION

Senator Linda Dorcena Forry

A t the 2014 annual St. Patrick's Day Breakfast in South Boston, State Senator Linda Dorcena Forry made history. Her first turn as the host of the much-ballyhooed event proved a political, cultural and gender "hat trick" of what had always been the Boston Irish "boyos" ruling the podium. A Haitian American and the first woman to run the show, Dorcena Forry, married to well-known Boston Irish journalist, editor and publisher William P. Forry—"Boston Irish by marriage"—turned stereotypes of the breakfast on their proverbial heads.

Historically speaking, there are other stereotypes about the breakfast that aren't completely accurate. If you ask many in these parts how long the breakfast has been a tradition and how it has been run and by whom, the answers might run from "always" and "always men" since the first breakfast and parade (officially in 1901). Many people would also assume that the event has always been a "political roast." The actual answers are foggier. In fact, a case can be made that the annual breakfast started as a dinner or a banquet.

South Boston's St. Patrick's Day Breakfast owes a historical nod to the Charitable Irish Society. The venerable organization can lay virtually undisputed claim to the first St. Patrick's Day event not only in Boston's history, but also in America's. It was also the first to feature food and drink. On March 17, 1737, in the heart of Puritan Boston, twenty-six men gathered to commemorate a decidedly Improper Bostonian event. They were men with Irish roots and living in a place where most locals loathed anything

that smacked of "Popery." Celebrating a Catholic saint's holy day could well have proven a risky proposition.

The reason that the twenty-six men pulled it off was that they were Protestant; however, since some were formerly Roman Catholics who had "embraced" a new faith, their devotion to Protestantism may have been wan. The religious question aside, the men drew up a charter that professed their pride as sons of the Emerald Isle, and they were meeting on the day dedicated to Ireland's patron saint.

The first St. Patrick's Day celebration of the Charitable Irish Society did not take place in Southie. Of the first members of the Charitable Irish Society, historian James Bernard Cullen writes, "An important part of the membership of the Charitable Irish Society was the Irish Presbyterian Church, established in Boston in 1727. They first worshipped in a building which had been a barn on the corner of Berry Street and Long Lane [now Channing and Federal Streets], and this unpretentious building served them, with the addition of a couple of wings, till 1744."

Despite Boston's vehement prejudice toward Catholics in the eighteenth century, the society ignored the religious restriction in 1764. Ever since, the society has held a dinner each St. Patrick's Day, toasting the old country and its patron saint, with the exception of a few gaps such as the American Revolution.

The Charitable Irish Society's centennial celebration, held on March 17, 1837, featured a format that seems a distinct precursor of the South Boston breakfast. The festivities offered a special list of guests, comprising a who's who of Boston's movers and shakers: "Governor Edward Everett, Mayor Samuel A. Eliot, Hon. Stephen Fairbanks, President of the Massachusetts Charitable Mechanic Association, the Rev. Mr. John Pierpont, the Hon. John P. Bigelow, Hon. Josiah Quincy, Jr. and numerous other luminaries."

Fairbanks delivered an address testifying to the fact that Boston Irishmen, both Protestant and Catholic, were indeed making their way in the city. In no way was the event a roast; it was a meeting of notable politicians and businessmen.

The historical seeds of the breakfast also began to sprout—and did so in Southie—as Irish immigrants landed in Boston in ever-increasing numbers in the 1840s and staked their claim to a new life in America. One of the early manifestations of the local Irish love for their old sod's patron saint was the Shamrock Society, a social club that gathered on March 17 to defiantly toast the saint and "sing the old songs," the revelers' voices

pealing from Dooley's Mansion House, and Jameson's. No single building, however, would long serve to hold the growing numbers of local Irish longing to celebrate in a bigger way. A historian noted, "No banquet room was big enough to comprehend all the Sons of Erin, even had they had the price of dinner."

Dinners and banquets, but not yet official breakfasts, followed the St. Patrick's Day Parade organized by the Ancient Order of Hibernians, which numbered some eight thousand members in Boston alone by 1900. Bands, organizations, refreshments—all were handled by the Hibernians' Entertainment Committee. In the hands of Ward 17 boss "Pea Jacket" Maguire and other Boston leaders, fun, festivities and pride in Irish roots ruled the city on March 17.

In March 1901, the blare of bands and the vibrations of marchers' feet pealed above South Boston's streets in the first official, city-sanctioned South Boston St. Patrick's Evacuation Day Parade. In the wake of the first official South Boston parade came a post-march celebration. Dignitaries in natty overcoats and top hats, figures such as Mayor Thomas Hart, stepped from the open, horse-drawn carriages in which the city's "high and mighty" had ridden in the parade and dashed into venerable Faneuil Hall for an official St. Patrick's Day banquet.

It was hardly the politicos alone whose party went on after the parade. Hordes of marchers and spectators streamed back to South Boston. At parish halls, in private homes and in watering holes throughout the ward, the celebration of "all things Irish" continued. A throng of Boston Irish jammed every inch of Gray's Hall, nestled at the junction of Emerson Street, for the South Boston Citizens' Association banquet.

According to John Allison in his article "History of the St. Patrick's Day Breakfast," the first public mention of the breakfast came in March 1909 in the *South Boston Gazette*. At the Bellevue Hotel, Mayor George Hibbard hosted an 11:00 a.m. breakfast before the parade. The revelers included local and state politicians and military officers. Still, the breakfast was not held in 1910–11 so had not become an annual event, and certainly not one paid for by the city, as Hibbard's event had been. Interestingly, no speeches were made nor jibes exchanged at the 1909 gathering.

Only when the city appropriated funds for the breakfast was it held intermittently from 1910 to 1920. In 1921, no breakfast took place, but 1925 brought about both a breakfast and a pair of St. Patrick's Day controversies. First, the Boston post office seized a shipment of shamrocks from Ireland and released them for the breakfast and parade because of

pressure from politicians and civic groups. A row over invitations to the breakfast took place when J. Philip O'Connell, Boston's director of public celebrations, reserved twenty-four of ninety seats for city officials, but the evacuation committee griped that he did not leave them enough seats for other dignitaries. Newspaper coverage of the disputes referred to the St. Patrick's Day gathering as the "Mayor's Breakfast."

Perhaps the most notable aspect of the 1921 event was the resemblance it bore to today's breakfast. "Himself"—Mayor James Michael Curley—gave "a witty speech" in which he leveled barbs at friends and foes alike. E. Michael Sullivan then stood up and sang "The Wearing of the Green."

Of the 1925 gathering, Allison writes: "These traits identify this breakfast as a very close ancestor of today's event. However, it was still not an annual event. By World War II there was no mention of a breakfast."

City Councilor Joseph Scannell hosted Mayor Maurice Tobin at an informal gathering before the 1941 parade, but few mentions of any St. Patrick's Day gathering during the war years of 1942–44 appear in the papers. In March 1945, the *Boston Gazette* related that supporters of Mayor John Kerrigan wanted to hold a breakfast reception for him before the parade. In a move that would seem incomprehensible today, Kerrigan nixed the idea because he "did not want any political demonstrations."

Politics and a turf war of sorts surrounded both the intermittent breakfast and the annual parade in the years after World War II. Since 1901, the South Boston Citizens' Association had ruled the St. Patrick's Day roost. The Allied Veterans Council argued that because the parade was largely "a military procession," they should run it and the pre-parade gathering. In 1947, the two organizations held separate "corned-beef banquets" before the parade; the following year, both organizations not only held pre-

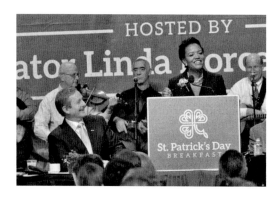

State Senator Linda Dorcena Forry made history in 2014 as the first woman to host South Boston's traditional St. Patrick's Day Breakfast. *Boston Irish Reporter photo.*

64

parade meals but also appointed their own chief parade marshal. Curley, who, as mayor, traditionally selected the marshal, appointed the Veterans Council and, Allison writes, "suggested that the Citizens' Association nominee could be the chief marshal's adjutant."

From 1951 to 1960, the pre-parade meal was a luncheon—actually, two luncheons. The city council luncheon hosted by the mayor was held at the South Boston Athletic Club, and state officials attended an affair at Dorgan's Old Harbor with Senator John Powers serving as host. Eventually, Powers's event superseded the mayor's, with the papers anointing him "St. Patrick's Day toastmaster," a precursor to the role that William Bulger took to a whole new level of wit and rhetorical flourishes.

What made the 2014 breakfast so noteworthy is that, at least since John Powers ran the show at Dorgan's, the sitting senator of the First Suffolk Senate District has followed suit. That 'suit" has always been filled by Irish American men with such names as Powers, Moakley, Bulger, Lynch and Hart. Now it was Linda Dorcena Forry's turn to host the St. Patrick's Day Breakfast. Her debut literally wrote a new and fitting chapter in the annals of Boston and the Boston Irish.

Part V

TALES OF THE SEA

13

"WHERE WILL I BE BURIED NOW?"

A Passage to Boston

In 1847, a crisis unfolded nearly daily along Boston's docks. Leaking, lurching vessels aptly dubbed "coffin ships" unloaded hordes of ragged Irish passengers who had fled the Great Famine, *An Gorta Mor*. Some twenty-five thousand arrived in "Black '47," with thousands wracked by "ship fever," likely a form of typhus.

Boston officials so feared a citywide epidemic that they ordered a medical receiving room erected on Long Wharf. As overwhelmed physicians dispatched the gravely ill to hospitals, the City of Boston frantically made emergency preparations to set up Deer Island as "the place of quarantine for the Port of Boston."

The swelling influx of Irish crowding Boston-bound famine ships posed such a health risk that local leaders deemed it "a settled matter that the City must support a Physician at Deer Island, and that is the suitable and proper place to attend to all of the nuisance and sickness accompanying the navigation."

The Deer Island Quarantine Hospital and Almshouse was established in 1847. All famine ships plodding into Boston Harbor and judged by port officials to be "foul and infected with any malignant or contagious disease" were moored at Deer Island until the port physician quarantined Irish men, women and children suffering from typhus, cholera and an array of fevers and oversaw the "cleaning and purification" of ships. Only then could the healthier immigrants set foot in Boston. From 1847 to 1849, approximately 4,186 people were quarantined at Deer Island "as a precautionary measure

Deer Island Almshouse, where many indigent Irish immigrants passed through. *Ballou's Pictorial. Courtesy of Boston Public Library Newspaper Archives.*

to ward off a pestilence that would have been ruinous to the public health and business of the city." Not all were to make it off the island.

Even before Bostonians grasped the health hazard posed by famine ships clotted with direly ill passengers, the Irish newcomers were not welcomed. In 1847, the city was changing—and its Yankee population did not welcome that change. As the shiploads of famine Irish arrived almost daily, Anglo-Protestant families who had ruled over the city since their Puritan ancestors set foot in the region in the 1630s embraced still the anti-Irish, anti-Catholic prejudice of Boston's founders. Ephraim Peabody, whose family ranked high among Boston's founding fathers, lamented that the Irish were infesting the local landscape with a horrific "social revolution."

As the city's population swelled from some 115,000 to over 150,000 in just 1847, the newcomers quickly discovered that they were not welcome. They had escaped the famine only to find themselves in a new battle for survival among what historian George S. Potter dubbed "the chilly Yankee icicles."

The age-old prejudices that the Irish had encountered on the "old sod" now confronted them in the New World, and as some one million Irish poured into America from 1845 to 1850, the roughest reception awaited them in Boston. For many, the first and last site they would see in America

was the Deer Island Quarantine Station. It was scant surprise that so many Irish reaching Boston were sick after the perilous six-to-eight-week Atlantic crossing from famine-ravaged Ireland. During the Great Hunger, over one million people perished in Ireland from starvation and associated diseases between 1845 and 1852. Over two million immigrated to the United States, Canada, Australia and other sites, and roughly six percent of the Irish immigrants fleeing to Boston and other North American cities died at sea from disease or went down with vessels ill-suited to the crossing.

Before Boston-bound Irish caught their first glimpse of the city or Deer Island, they endured physical and emotional nightmares that few had ever encountered. The logs and records of famine ships sailing to Boston and elsewhere recorded unforgettable scenes of human fear and misery. In an 1848 letter penned by British official Stephen F. De Vere, the description of the berths was chilling: "The passengers have not more [room] than their coffins."

A Parliamentary Report of the Select Committee to Investigate the Operation of the Passengers Acts related: "I have known cases of females who had to sit up all night upon their boxes in the steerage," said one eyewitness, "because they could think not of going into bed with a stranger man."

With men and women packed tightly into steerage, there were no means to preserve even a semblance of privacy or modesty. Fevers spread rapidly and lethally. Irish men, women and children thrashing with sickness and crying out in their fitful sleep were dazed by the growing realization that no matter whether their ship went down in a storm or disgorged them at Deer Island, they had glimpsed Ireland for the final time. An elderly woman, slumped against the rail of a coffin ship, exclaimed, "God save me. Old as I am, I should never have left Ireland. Who knows where I'll be buried now."

For some 721 to 850 Irish—various sources place the number as high as 1,000—between 1847 to 1850, the burial place proved to be Deer Island's Rest Haven Cemetery. Of 4,816 persons admitted to the hospital from its opening in June 1847, to January 7, 1850, 4,069 were ailing. At least 759 (15.8 percent) died on the island. Figures as to how many were buried in an unmarked grave vary, because a number of bodies were claimed by family members and buried elsewhere in or around Boston. Those who were unclaimed—literally dying alone—were laid to rest on the island at the City of Boston's expense.

Many immigrants who were not weak enough for quarantine on Deer Island did not last long in Boston's North End Irish tenements and rooming houses, where conditions were little better than on the crowded coffin ships.

A Boston Committee of Internal Health study of the slums related that the Irish languished in "a perfect hive of human beings, without comforts and mostly without common necessaries, in many cased huddled together like brutes, without regard to age or sex or sense of decency. Under such circumstances self-respect, forethought, all the high and noble virtues soon die out, and sullen indifference and despair or disorder, intemperance and other degradations reign supreme."

The lack of sanitation in the slums unleashed a wide array of disease, cholera proving the most lethal. Of Irish children born in Boston during the famine years, approximately 60 percent died before the age of six.

Today, a long effort to erect a memorial to the immigrants buried on Deer Island has come to fruition. A stately, somber granite Celtic cross faces the Atlantic. The dream of the late Dr. William O'Connell and his wife, the late Rita O'Connell, the memorial stands as a poignant and dignified symbol of the Irish who fled their famine-gutted country and survived the terrifying ocean crossing, only to perish on Deer Island. Rita O'Connell noted, "It's important we don't forget the stories of people such as Patrick J. McCarthy, who lost his mother, father, and six siblings on Deer Island but went on to graduate from Harvard and become mayor of Providence [Rhode Island]."

"BRIDGET SUCH-A-ONE..."

The Wreck of the Brig St. John

As each October arrives, it brings a tragic local anniversary. The tragedy is one that especially resonates now, with America torn along political, racial, ethnic and religious seams.

The catastrophe engulfed desperate Boston-bound immigrants off the shore of Cohasset, Massachusetts, on October 7, 1849. Even as disaster hit, common humanity trumped nativist prejudice for an all-too-brief moment.

Henry David Thoreau had never seen anything like it. On October 8, 1849, he wandered the shore of Cohasset and gaped at the wreckage of the *Brig St. John*, a Boston-bound merchantman that had sailed from Ireland "laden with emigrants" fleeing the Great Famine. The vessel was one of some sixty emigrant ships, or aptly named "coffin ships," lost at sea or smashed upon crags off America's eastern coast.

As Thoreau surveyed the scene, he poured into a notebook a torrent of words that captured the gut-wrenching spectacle: "I saw many marble feet and matted heads as the cloths were raised, and one livid swollen and mangled body of a drowned girl—who probably had intended to go out to service in some American family....Sometimes there were two or more children, or a parent and child, in the same box. And on the lid would perhaps be written with red chalk, 'Bridget such-a-one, and sister's child.'"

On October 7, 1849, the brig *St. John*, five weeks out of Galway Bay and packed with Irish immigrants fleeing the Great Famine, was hurled by a gale onto the jagged rocks of Grampus Ledge, off Cohasset, Massachusetts. A second "coffin ship," the *Kathleen*, grounded safely nearby on a sandbar.

As the *St. John* broke in two on the rocks, immigrants and crewmen thrashed in the foaming surf. Eyewitness Elizabeth Lothrop wrote that "no human power could stay the waves," which pulled the brig "deep into the depths of Hell."

On the shore, the boatmen of Cohasset—Yankees with little affinity for the Irish—left prejudice on the beach as they tried again and again to launch the town's lifesaving boats into the crushing surf. Led by Captain Daniel T. Lothrop, a Cohasset "salt," Elizabeth Lothrop wrote, that the rescuers "struggled through the enormous waves for nearly forty-five minutes before reaching the area of the *St. John*. It was then that they noticed the longboat rowing to shore, with Captain Oliver [of the *St. John*] and the crew of the ship. The captain made no mention to the lifesavers that passengers had been left behind on the wreck to fend for themselves. Accordingly, the lifeboat proceeded to the *Kathleen*, the rowers unaware that numbers of people may yet have been desperately clinging to the remains of the *St. John*. The magnitude of the tragedy only became apparent after the lifesavers had returned to shore and learned that the immigrants had been left stranded on the wreck."

The rescuers managed to aid only the *Kathleen* in the end. Most of the *St. John*'s passengers perished in the towering waves. Over the next few days, 45 bodies washed ashore, and the townspeople buried them in a common grave. An exact total was never possible to ascertain. At least 99 people drowned; 11 survived. In all, up to 145 may have been lost.

Among the most heartrending stories of the disaster was that of Galwayman Patrick Sweeney and his family. Sweeney, his wife and their nine children had boarded the vessel in hopes of a new and better life in Boston. As the brig broke apart on the rocks, Patrick could do nothing as his wife and eight of their children vanished in the frothing waves. Clutching his three-year-old daughter, Agnes, he jumped into the water and swam frantically toward the longboat. A massive wave broke across father and daughter. They, too, disappeared; their bodies were never found.

Adding additional agony to the fate of the Sweeneys and so many of their fellow immigrants and pointing a finger at Captain Oliver, Captain Lothrop testified that if he had only been told that there were passengers clinging to the brig's pieces, he might well have been able to rescue some of them.

The tragedy claimed one last victim on the Cohasset shore. An Irishwoman who had rushed to the scene from Boston in hopes that her infant daughter and her sister had survived the shipwreck found their corpses beneath a

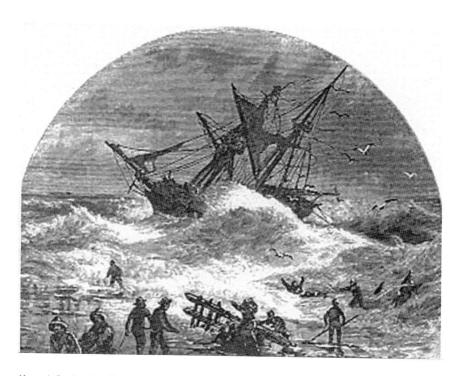

Above: A famine "coffin ship" sinking in a storm. Harper's Weekly, *Library of Congress*.

Right: *Brig St. John* monument, Cohasset, Massachusetts, honors famine refugees who perished in a gale within sight of America. *Photo by Peter F. Stevens*.

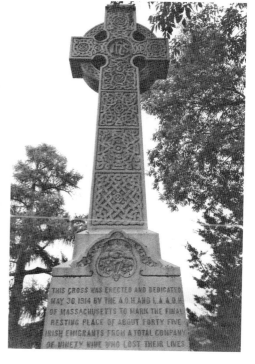

sheet on the sand. "The infant [was] tightly folded in the sister's arms," Elizabeth Lothrop remembered. "The mother died of heartbreak."

The infant and at least forty-four other victims were buried in a "great common grave" near the Cohasset shore, and the matter of a proper ceremony for the Catholic dead was raised. As the Ancient Order of Hibernians notes, "It was then that the nearest priest, Father John T. Roddan, of Quincy, was asked to come to [Cohasset]. It was within a day or two after the storm that Father Roddan blessed the great common grave that held the remains for forty-five emigrants. This, in turn served as a catalyst for Cohasset Catholics to begin petitioning Boston for a church of their own."

In 1914, the Massachusetts Loyal Order of Hibernians raised a nineteen-foot Celtic cross near the victims' common grave. Today on display at the Cohasset Maritime Museum is all that is left of the ill-fated brig: a trunk, a small writing desk and a piece of one of the ship's pulleys.

Many of the locals who had witnessed the tragedy and its aftermath could not shake the images. Elizabeth Lothrop would write that "such a set of half-drowned, half-naked...frightened creatures [survivors] my eyes never beheld....The horrible shipwreck and the continual picking up of dead bodies on our beach has so excited my mind that I...shall never get over it."

A great many modern Irish Americans have forgotten or simply do not care about their families' own immigrant ancestors. They were once "the other," the targets of nativist rage. Still, perhaps, there is some historical hope in that long-ago tragedy off Cohasset, when Yankee Protestants, who often loathed the "ragged Irish," forgot all that and rowed into the gale, risking their lives to aid desperate immigrants who were floundering within sight of America's "Golden Door."

Part VI

CHURCH AND STATE

A Tale of Two Churches

A Cathedral and a Little Stone Chapel

Today, as the Boston Archdiocese confronts financial issues, parishes throughout the region pray that they will escape the "hit list"—the list of churches to be closed. St. Augustine's Chapel and Cemetery and the Cathedral of the Holy Cross reflect both the changing time and the memories of bygone days.

Both sites stir the soul, but in different ways. One stands in soaring Gothic tribute to the Irish Catholic immigrants who endured religious and ethnic bigotry to make their way in Boston and New England. On a rain-spattered day, the other site's sodden stones stand as sober reminders of the hardships endured by the city's early Irish immigrants. These two sites are the Cathedral of the Holy Cross and St. Augustine's Chapel and Cemetery.

In 1779, when Massachusetts's leaders drew up the state's constitution, they added a startling proviso. For the first time, they proved willing to give at least tacit acceptance to the handful of Irish and French Catholics in Boston. No longer would local Irish have to assume membership in other churches, masking or even shedding their traditional faith, as the legislature could no longer enact overt statutes against Catholics. To the ire of many Yankees, the proverbial religious genie—"popery"—was slipping from its centuries-old restraint in the region.

Not many Catholics had actually practiced other than in private. But now, in a development that would have horrified the Mathers and other Puritan luminaries a century earlier, a French priest named Abbe de la Poterie showed up in Boston and invited Catholics to attend services in an old

Huguenot church perched on School Street. There, on Sunday, November 2, 1788, a handful of Irish and French Catholics heard the first legal Mass in Boston's annals.

De la Poterie read the Mass in Latin, but with a thick French accent that proved difficult for the Irish to follow. Still, the language barrier notwithstanding, Doyles, Callahans, O'Briens, Fitzpatricks and other Irish émigrés crowded into the little church on School Street.

As two years passed and another Frenchman, Father Rousselet, replaced de la Poterie, some of the Irish became frustrated by French-accented sermons that they could barely follow—if at all. They began to slip away from services, muttering that they would return only when a priest fluent in English arrived.

That curate finally strode to the local church's diminutive altar on January 10, 1790. To many Proper Bostonians, Father John Thayer was a religious turncoat. He had been born and raised a Congregationalist and had studied at Yale, a bastion of the era's traditional American Protestantism. Then, he traveled to France and Italy, developing an interest in Catholicism. His interest soon burgeoned into a full-fledged vocation, and in 1787, he was ordained a priest in the Catholic Church. The new cleric had a missionary task in mind: return to his old home and organize a bona fide parish.

What made Thayer's appearance in Boston so unpalatable to his family, friends and neighbors was not only his conversion, but also his abandonment of the career that he had trained for: Congregationalist minister. His path to the School Street pulpit delighted the small band of local Irish and attracted back to Mass those who had turned their backs on the French priests' services. But while he was greeted eagerly by the local Irish, his reception from the Protestant community and French Catholics alike was decidedly different. The language of one Bostonian typified Yankee sentiment toward Thayer. He "commenced his Life in Impudence, Ingratitude, Lying and Hypocrisy, irregularly took up preaching among the Congregationalists, went to France and Italy, became a Proselyte to the Roman Church, and returned to convert America to that church." The writer, Ezra Stiles, harangued the new priest as a man "of haughty, insolent and insidious Talents."

French Catholics, naturally happy with Rousselet, who spoke their own tongue, viewed Thayer as a "usurper" of the small inroads the local parish had made. At first, when he got off to a proper start by deferring to Father Rousselet, the French accorded the new priest a "wait-and-see" attitude.

Thayer exercised an immediate impact on the local Irish. As Professor Thomas H. O'Connor writes in the *Boston Irish*, "The Irish, especially,

were pleased finally to have an English-speaking curate at their disposal." O'Connor reveals that the Boston Irish "began to attend church services in greater numbers, brought their children (some as old as 16) to be baptized, and had their Protestant marriages solemnized in the Catholic Church."

Eagerly aiding Father Thayer in his personal mission to establish an English-speaking parish were the Irishmen and Irishwomen who had long awaited a church of their own. His chief helpers were immigrants who had established roots in New England prospering in trades and businesses, blending into the Protestant population and attending Anglican services—the closest they could find to their former faith. With such names as O'Connell, Magner, Mulligan, Harrington and Maloney, they came out of the religious shadows to practice their faith in the open despite the certainty that no mere words in the state constitution could quickly erase centuries of religious antipathy between them and their Protestant neighbors.

Father Thayer's arrival soon swelled the ranks of practicing Irish Catholics to roughly five hundred in 1790, but his combative style on and off the altar outraged Yankees and tore a rift between the city's Irish and French Catholics. Before long, Thayer and Rousselet were at odds. Each cleric, in a real sense, was ministering to parishioners divided along lines of language, English and French. Father Thayer did bring an unprecedented degree of religious organization and identity to the local Irish, "but [his] tactless zeal…his uneasiness under ecclesiastical restraint, and his egotism" doomed his self-avowed mission. Thayer's vitriolic jabs at local Protestants ignited Yankee calls to rein in Boston's fledging Catholic church.

In Baltimore, Bishop John Carroll, the architect and guardian of the progress Catholicism was making after the Revolution, rescued the Boston Irish church by dispatching both Thayer and Rousselet to less incendiary assignments. Carroll replaced them with Father Francois Matignon, thirty-eight years old and a savvy, diplomatic man palatable to many of the Protestant community.

Matignon, with the later aid of Father John de Cheverus, mended the tear between the Irish and French, repaired the aged church on School Street and assuaged many local leaders' concerns that the Catholic parish posed any threat to Congregationalists or Anglicans.

The two clerics were so successful that the original church could no longer hold the numbers of Irish, who composed, by 1799, the bulk of the parish and wanted not only to hear Mass but also to establish a real parish community. On March 31, 1799, the priests and their parish's most influential laymen

came to a portentous decision: with the church's attendance now more than one thousand, the time had arrived to raise funds to build a new church, a real church. Donations from poor and better-heeled worshipers alike allowed Father Matignon to purchase a parcel of land on Franklin Street and to hire Charles Bulfinch, the designer of the just-completed Massachusetts State House and the rising star of local architecture, to craft Boston's first building specifically intended for Catholic worship.

Just a few decades earlier, the very notion of a "Papist Temple" would likely have sent a mob into the streets. However, by the turn of the nineteenth century, the political "bridge-building" of Fathers Matignon and Cheverus had literally opened a religious route for Boston's Irish Catholics. The two priests won enough local support not only to build a Catholic church but also to convince such Protestant luminaries as President John Adams to sign the church's subscription list.

On September 29, 1803, one of the most important days in the pre-famine annals of the Boston Irish unfolded on Franklin Street. The day was Thursday and the Feast of St. Michael the Archangel. Surveying the throng packing every inch of the now-completed Church of the Holy Cross, Bishop John Carroll celebrated a High Mass with all of the ornate trappings to dedicate Boston's first genuine Catholic church.

An eyewitness recorded how the unprecedented scene marked a landmark moment for Irish immigrants "who were drawn here by the miserable conditions that existed in their native country."

For the first time, the Irish had their own local foothold where they could practice their faith and where, on the walls of Bulfinch's design, the hard-won right to practice their ancestors' religion was literally written in stone. Many Protestant neighbors would still battle but never erase that foothold.

Having established a genuine parish church, Boston's Irish Catholics soon turned their concerns—as well as their donations—to find a site where they could bury parishioners in consecrated ground. In 1818, the archdiocese purchased a South Boston tract that became St. Augustine's Cemetery. Boston's Board of Health recognized "that group of Christians known as Roman Catholics." The cemetery and chapel took shape at the corner of Dorchester Street and West Sixth Street. The chapel was finished in 1819 and stood as the first Gothic-style Catholic structure in Boston. In the cemetery, simple slabs, more ornate Celtic crosses and many other makes and sizes of markers would bear mute but eloquent testimony to the "footsteps of the Gael" in Boston. Among the oldest stones are those recalling the names

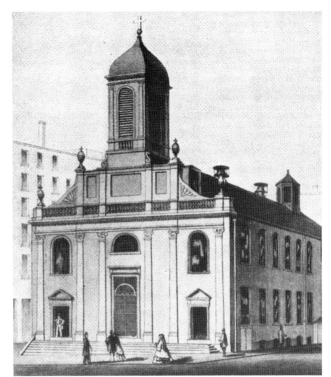

Right: Church of the Holy Cross, Boston's first bona fide Catholic Church, 1803. *Courtesy of the Archdiocese of Boston.*

Below: St. Augustine's Cemetery, South Boston, was the first official burial ground for Irish Catholics in the city. *Photo by Peter F. Stevens.*

of men and women who endured much prejudice in Boston but lived long enough to attend Mass at their own church.

Bishop Joseph Benedict Fenwick, throughout the 1820s, enlarged the chapel; then, in 1868, St. Augustine's Parish was created, with a new church to rise under the pastorship of Father Denis O'Callaghan.

The walls of the original church are long gone, but the Gothic splendor of the Cathedral of the Holy Cross, in the South End, echoes the triumph of its Franklin Street namesake. For anyone seeking more tangible proof of that victory, the stones of St. Augustine's Cemetery offer somber reminders.

The Church Lady

Mysterious Mary Lobb

Being Irish in colonial Boston posed difficult, often impossible hurdles. In the post-Revolutionary era, however, local Irish slowly emerged from religious shadows despite intolerance and outright bigotry from many Protestant neighbors. One of the boldest to step forward was a widow named Mary Lobb.

The *History of the Archdiocese of Boston* records that Lobb was "born in 1734, the daughter probably of Patrick Connell, mariner and sea-captain." What remains unclear is whether her birthplace was Boston or Ireland.

What is clear is that like most Bostonians with Irish roots, she "converted" with her family to one of the town's Protestant faiths, the Anglican Church in her case. There was virtually no other way to subsist, let alone thrive, in the community. Her children were baptized as Anglicans.

If living quietly to get along with one's neighbors was the best route for anyone with an Irish surname in the town, Lobb took a decidedly different tack. Local historian and author J.L. Bell, who has conducted a great deal of research on Lobb and her often-fractious family, writes, "Being a widow with young children didn't make Mary Lobb unusual in eighteenth-century Boston. Even living apart from her second husband probably wasn't that odd, especially after the disruption of the war [the Revolution]....

"What makes Mary Lobb notable is that she became a stalwart Catholic. It's quite possible that Mary Lobb had long thought of herself as a Catholic."

Lobb saw that change was coming to "Old Boston." She and a small but growing community of Irish Catholics were testing the tenets of religious

freedom quietly but openly with Mass at an old, ramshackle Huguenot church on School Street. Today, that church is long gone, and passersby walk past a small marker commemorating just how important the site once was in the annals of the Boston Irish.

Samuel Breck, a local, described the effort to launch the church: "We fitted up a dilapidated and deserted meeting-house in School-street that was built in 1716 by some French Huguenots, and it was now converted into a popish church, principally for the use of French Romanists. A subscription put the sacristy or vestry-room in order, erected a pulpit, and purchased a few benches. A little additional furniture and plate was borrowed."

Among the most ardent new parishioners was Mary Lobb. Thomas H. O'Connor, in *Boston Catholics*, writes, "One of the first and most active members of Father Thayer's little congregation was Mrs. Mary Lobb (née Mary Connell), widow of a sea captain."

Lobb was much more than an engaged parishioner. The *History of the Archdiocese of Boston* reveals that "Father [Francis] Matignon [Thayer's successor] lived at the house of Mrs. Mary Lobb, in Leverett's or Quaker Lane (now Congress Street), in what was a small Catholic section." So, too, did Abbé John de Cheverus, Matignon's assistant.

Archdiocese records show that when the time came to erect a new and larger house of worship, which became Boston's Church of the Holy Cross (1803–circa 1862), Mary Lobb contributed a sizable donation. In 1810, she supported literary pushback against anti-Catholic screeds. She died sometime during or near 1817, but her story was not yet finished.

As J.L. Bell has uncovered, shortly after Lobb's death, a bitter legal battle between a grandson and a tenant/caretaker erupted over her estate. The tenant, William Jordan, contended that Lobb had signed over a property to him in her amended will and had negated the original will, which, Bell writes, stipulated that she "left one of her properties to a seven-year-old grandson, Francis Campbell Smithwick," and that Jordan would be the boy's guardian and manage the property until the boy turned twenty-one. The grandson's family sued Jordan. In turn, Jordan produced deeds signed over by Lobb to Jordan.

The court decided that Jordan had taken advantage of Lobb, who had displayed "evidence of extreme old age and imbecility" and "habits of intoxication." The decision chided Jordan, struck down his claim and set up a trust fund for the grandson.

Her strange postmortem episode notwithstanding, Mary Lobb played a key role in the struggle for freedom of religion in Boston.

"No Care Will Be Spared"

Bishop Fenwick's Boston Irish Colony

I n 1834, Bishop Benedict Fenwick agonized over the plight of Boston's
Irish immigrants. He had reason for concern. The city's Irish population
had swelled to more than seventy thousand, most of them living near
the waterfront on and around Broad and Ann Streets. They lived in decrepit
flats that "swayed at the merest hint of a breeze."

Along with the squalid, disease-wracked conditions beleaguering his
Irish parishioners, another problem distressed Bishop Fenwick. Anti-
Catholic, anti-Irish passions, deeply embedded in New England's Puritan
traditions, were swelling in Boston. Attacks in print against Irish immigrants
denounced them as agents of a papal plot to take over America from
"right-thinking Anglo-Saxons." In 1834, the *New England Magazine* railed
that "with their poverty and their propensity to drink to excess, they [the
Irish] become a most dangerous engine in the hands of designing and
bad men, to overawe and control our native citizens." A minister derided
the newcomers as "idle, thriftless, poor, intemperate, and barbarian wild
bison," assaulting "civilized domestic cattle."

Bishop Fenwick knew better. While acutely aware of the social woes that
poverty and alcohol caused in the city's tenements, he also knew that most of
his Irish-born flock worked hard to provide for themselves and their families.
He saw them taking any jobs, no matter how menial and low paying, to
survive, and he wanted better for them. But even the sight of the Irish loading
and unloading ships, sweeping the streets and working other backbreaking
jobs for a pittance bred trouble for the Irish. Historian Thomas H. O'Connor

writes that "as the rate of immigrants went up noticeably, local [Yankee] workers became fearful that the impoverished and undesirable newcomers, the brogue on their lips and mud on their boots, would work for slave wages and take away their jobs."

The bishop's anxieties for his diocese swelled in 1834, when antipathy toward the city's Irish exploded from printed and verbal harangues to new levels of violence. For nearly a decade, gangs of Yankee laborers had intermittently attacked Irishmen along Ann and Broad Streets and vandalized neighborhood shops and homes, crimes that even the traditional Boston newspapers condemned as "disgraceful riots." In 1834, the local papers chronicled an escalation of such incidents. Most alarming among them for the immigrants and their bishop was the burning of the Ursuline convent in Charlestown in the summer of 1834 by a mob of Yankee workmen. For the bishop, an idea sparked by those events materialized: he wondered whether some of the city's Irish might be better off "in the country," away from the squalor, illness and violence of Boston's waterfront slums.

Central to Fenwick's evolving plan were utopian tenets embraced by many American intellectuals both Catholic and Protestant. As the nation's cities became more crowded and rife with social problems, the appeal of rural regions as an outlet for the pent-up energies of poor immigrants and native-born Americans increased. Languishing in the cities appeared not a viable idea to movers and shakers from Horace Greeley ("Go West, young man") to Bishop Fenwick.

Fenwick, always a man of action, proved true to form once he convinced himself that a "Catholic colony" in the country would offer some, if not all, of Boston's Irish a fresh start. Aware that many immigrants had been displaced from agrarian Ireland, he reasoned that a return to their proverbial roots was possible "in the wilderness." Having traveled extensively throughout New England, the prelate chose a site in Maine's southern Aroostook County for the Catholic settlement he envisioned. With its rolling, wooded hills, its clean water and its rich soil, the countryside appeared perfect for his purpose. Fenwick hoped that for any "Boston Irish who longed for the chance to escape the crowded city to farm their own land [and] to practice their faith free of Nativist prejudice, and to establish a unique Irish community in New England," Maine was the answer.

The bishop purchased eleven thousand acres for $13,597.00 in Aroostook, the tract in the western half of Township Two. Dividing it into lots of fifty, eighty and one hundred acres, he offered it to Boston's Irish for $2.00 an acre for land along the Aroostook Road (the rutted way serving as the region's

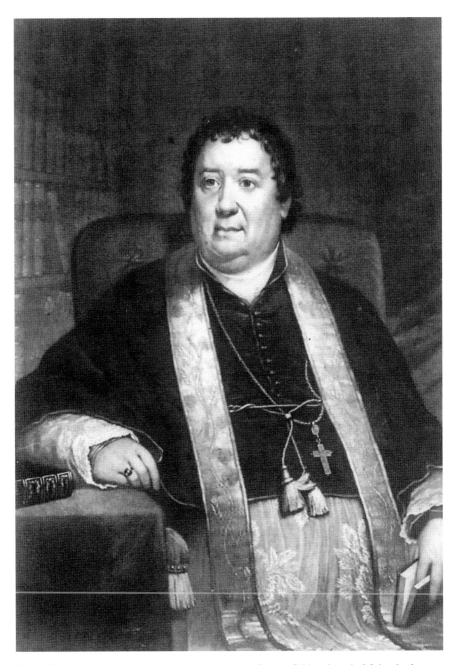

Bishop Benedict Fenwick, who attempted to plant a Boston Irish colony in Maine in the 1830s. *Courtesy of the* Boston Pilot.

stagecoach route) and for $1.50 an acre away from the road. Because few immigrant families could ante up the full amount for the lots, the archdiocese offered terms for interested parishioners. Fittingly, the bishop named the territory Benedicta.

By the early summer of 1834, Fenwick was running advertisements in the *Catholic Sentinel* (later the *Pilot*), the newspaper he had established in September 1829 not only to give local Catholics their own publication but also to "explain, diffuse, and defend the principles of the One, Holy, Catholic, and Apostolic Church." His advertisement sought "those industrious Irish families who wish to retire into the country from the noise and corruption of the cities in order to devote themselves to agriculture."

That the bishop's vision of Benedicta was one both agricultural and religious rang in another advertisement that appeared in his newspaper: "No care will be spared—to render this little colony one of the most happy and flourishing of the Catholic Church."

By the midsummer of 1834, a handful of Boston's Irish packed their belongings into battered steamer trunks, valises and sacks and boarded steamboats bound for Maine, the second time that most had trudged aboard vessels in search of a new start. This voyage was far shorter than the one from Ireland to America but was nonetheless filled with the same uncertainties and fears of what lay ahead. Once landed in Maine, Fenwick's first "colonists" trudged up the Aroostook Road. Within a year, 250 Irish had made that trip, and Bishop Fenwick, true to his word, aided his rural social experiment with the diocese's funds to erect a sawmill, dig a canal and raise the first building of what he conceived as a church and "college of Catholic learning, far removed from distractions." He planned to call that Aroostook institution the College of the Holy Cross.

At first, Fenwick was heartened by the early results at Benedicta. Regularly visiting his rural community, he lauded the farming skills of settlers bearing such names as Duffy and McAvoy; they soon planted the first potato crop in Aroostook County. To tend to the new church, beginning in 1834, a succession of priests was always stationed at Benedicta, "nearly all with comfortable Irish names like Conway, O'Haherty, Dougherty, Brady, Cassidy, O'Connor, Fitzpatrick, Houlihan, O'Hara."

Although Benedicta would be incorporated in 1873, its founder's lofty dream for an "Irish Utopia" in Aroostook County had ebbed long before. The College of the Holy Cross would be founded not in Maine but in Worcester, Massachusetts.

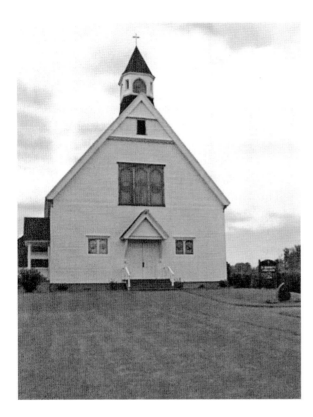

Catholic Church at
Benedicta, Maine. The
town's name derives from
Boston Bishop Benedict
Fenwick's "Irish colony."
Photo by Peter F. Stevens.

Notwithstanding the hardy souls who trekked up the stagecoach road in
1834, Boston's Irish generally opted to stay put. Their foothold in the city
was one of shabby dwellings, menial labor, disease, nativist prejudice and
every imaginable hardship, both physical and emotional. But the brutal
conditions Boston's first Irish neighborhoods endured bred an irrefutably
shared sense of community and a growing sense of strength in numbers.
Most had decided that Boston, as rough as it was for the Irish Catholics of
the day, was where they now belonged.

IN WAR AND PEACE

Father John McElroy

I n 1846, Father John McElroy would make American history—or perhaps more fittingly, history summoned him—with a letter directly from President James K. Polk. The Irish-born priest, later to earn fame as a founder of Boston College, was about to be named the first Catholic chaplain in the annals of the U.S. Army. His new post would place him center stage in one of the most explosive episodes in the army's history. His mission was to dissuade Irish immigrant soldiers abused by their American officers not to desert their regiments fighting in the Mexican-American War and not join fellow Irishmen who had "gone over the hill" to fight in the ranks of the Mexican army's St. Patrick's Battalion.

In early 1846, the Catholic bishops had formally objected to Polk about nativist officers physically abusing Irish Catholic soldiers and forcing them to attend Protestant services. Polk acknowledged that "much indignation was rife throughout Catholic circles over the punishment inflicted by fanatical military chiefs on Catholic soldiers who had refused to attend Protestant services sanctioned by regimental officials," and the president "expressed a great wish" for "the appointment of Catholic chaplains for the army" and asked "the Bishops to give him the names of two priests to whom commissions would be at once issued." The startled bishops turned to Georgetown College president Father Peter Verhaegen for help, telling him they needed two priests able to convince immigrant Irish soldiers who were not even citizens that their oath to the U.S. Army was sacred, no matter how much bigotry and physical abuse their officers heaped on them.

Verhaegen suggested a pair of fellow Jesuits: Father John McElroy, the pastor of Washington Trinity Church, and Father Anthony Rey, a Georgetown administrator. The bishops rushed the two names to the president.

Within a day, a letter from Secretary of War William Marcy arrived for McElroy at the rectory of Trinity Church. A native of Enniskillen, County Fermanagh, Ireland, the sixty-nine-year-old priest had been born in 1782. In his early twenties, he had boarded a flax ship bound for Baltimore and soon migrated to New York in 1803 and was ordained in Georgetown in 1817.

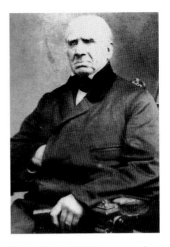

Father John McElroy, one of the U.S. military's first two Catholic battlefield chaplains and the founder of Boston College. *Courtesy of Library of Congress.*

No stranger to reminding fractious, wayward worshipers of their duty to God, even McElroy wondered whether he or any priest was up to the task outlined in the letter he held: "Sir—The president is desirous to engage two Reverend gentlemen of the Roman Catholic Church to attend the Army of Occupation on the Rio Grande to officiate as chaplains....His attention has been directed to you...in the hope that you may consider it not incompatible with your clerical duties or your personal feelings to yield to his request."

Marcy's phrase "your personal feelings" drove to the core of the religious issue: could McElroy, in good conscience, urge Catholic soldiers reviled by nativists to continue fighting against Catholic Mexico? McElroy, long convinced that America offered fellow Irishmen better prospects than anywhere else, regarded the signature on an enlistment form as sacrosanct. He accepted Polk's request.

Marcy informed the pastor "that the existing laws of the United States do not authorize the President to appoint and commission chaplains, but he has the authority to employ persons to perform such duties as appertain to chaplains." No one but Polk, his inner circle, the bishops and two priests would know for several weeks about the first Catholic chaplains in the history of the U.S. Army. If and when those chaplains arrived at the Rio Grande, Polk could claim that they were observers or visitors when nativists demanded an explanation.

The same letter was sent to Father Anthony Rey, a thirty-nine-year-old man known for his quiet, reassuring demeanor and deep faith. He, too,

immediately accepted. Marcy summoned the two Jesuits to his office a few days later. McElroy wrote that the secretary of war, a man with longish hair and a "poker-face, received us very affably and ordered his chief clerk to prepare letters for the Commander of different posts to facilitate our journey." Then, the president received the priests "with great kindness and regard."

Following the interview, Marcy "asked us what we thought sufficient for our expenses." The priests had no idea, but the secretary and Polk figured $1,200 in gold for each "by virtue of his discretionary power."

On May 29, 1846, Marcy sent two dispatches to Mexico, one to Lieutenant Colonel Thomas Hunt, the commander at Fort Polk (Point Isabel), the other to General Zachary Taylor. Both letters were labeled "confidential." Marcy explained the priests' "secret mission" to Taylor in the following fashion:

> *Sir—The President has…invited the Reverend gentlemen who will hand you this commission to attend the army under your command and to officiate as chaplains.…It is his wish they be received in that character by you and your officers, be respected as such and treated with kindness and courtesy, that should be permitted…with the soldiers of the Catholic faith, to administer to their religious instruction, to perform divine service for such as may wish to attend whenever it can be done without interfering with their military duties, and to have free access to the sick or wounded in hospitals and elsewhere.*

Polk's message to Taylor was clear; use the priests to keep Catholic immigrants, especially McElroy's fellow Irish immigrants, in the ranks and order nativist officers to show deference to McElroy and Rey—like it or not.

On June 2, 1846, the priests departed for the Rio Grande. They landed at Fort Polk on July 2, 1846, and opened their mission with a visit to the base hospital. Moving from cot to cot, the clerics comforted the wounded from the Battle of Palo Alto and Resaca de la Palma (in May 1846). Of the seventeen regulars McElroy and Rey consoled, fifteen were Irish. Many more craved the priests' ministration upriver at Matamoros.

McElroy and Rey soon boarded a small steamer and reached Taylor's headquarters at Matamoros four days later. McElroy wrote, "He received us in the most friendly manner and begged us to give the opportunity of rendering us all the service of power."

In late July 1846, the priests and General Taylor traveled to Camargo, about one hundred miles upstream from Matamoros. The priests visited camps flanking the San Juan River, a tributary of the Rio Grande, and

comforted thousands of men wracked by dysentery, the result of foul drinking water. Over fifteen hundred men would die from that malady and fevers in the hospital tents, the days and nights ringing with "the groans and lamentations of the poor soldiers." Stricken Protestant soldiers with no chaplains of their own called for the priests, who even performed their church's last rites to the many Methodists, Unitarians and Presbyterians who asked for solace. The clerics' presence did little to ease brutal discipline toward Irish Catholic soldiers. On a daily basis, McElroy and Rey heard nativist officers "justifying" their abuse of immigrants with such bromides as "poor Irishman…[were] the best material in the world to make infantry of, but required great efficiency on the part of officers to enforce discipline." A young West Point lieutenant huffed that "the officers will have to exert themselves greatly" to control lowly "Dutch and Irish immigrants." McElroy witnessed that even though some Germans in the ranks had fought Napoleon, many "officers exhibited disgraceful conduct toward them and had the idea in their heads that the common soldier is a being far below them."

"The menacing unmanly deception of the officers," as described by a private, vied with McElroy's and Rey's considerable powers of persuasion to keep Catholics from going over the hill.

McElroy found common ground with nativist officers on one point: contempt for the *New York Express*, one of the many American newspapers reaching the troops. It editorialized on the difficulties of the priests' mission: "They [Catholic troops] cannot but see and feel that the conquests… [and] that the native-born troops are Protestant, and that the inevitable consequence of such invasion is the subjection of the Mexican religion to the Protestant religion of the invaders."

Father McElroy had traveled downriver back to Matamoros and Point Isabel, reminding foreign-born troops that their duty was to remain in the ranks and "turn the other cheek" to nativism. In the camps, McElroy sermonized upon the same themes of duty and sacred oath. For hundreds of Irish-born listeners, his assertion was that the risks to body and soul for deserters outweighed the private hells many Irish and German Catholic soldiers suffered daily at the hands of tyrannical nativist officers.

An enemy that Father McElroy had seen assailing the troops threatened to silence him later in 1846. The foe was dysentery. Rising from a medical cot whenever he could, the priest attempted to carry on his mission. But in 1847, he was summoned back to the United States by the bishops. The quasi-secret mission of the priest was over.

Assigned as pastor to St. Mary's Church, an immigrant parish in Boston's North End, Father McElroy battled nativist prejudice daily with a gritty determination that his fellow Irish and Catholics would survive and eventually prosper in and around the city. By his death at the age of ninety-six in 1877, "the gallant, unconquerable Jesuit" had founded Boston College, a lofty achievement—so lofty that his status as one of the U.S. Army's first two Catholic chaplains would fall between history's proverbial cracks.

"GANGPLANK BILL"

Cardinal William O'Connell

In Lowell, Massachusetts, William Henry O'Connell's presence is still palpable in many ways. A glowering, broad-shouldered bust of His Eminence juts from Cardinal O'Connell Parkway near City Hall, his chiseled, tight-lipped visage testifying to a prelate who once presided over the archdiocese amid whispers of scandal. But the cleric's place in local and regional history remains formidable.

O'Connell was born in Lowell on December 8, 1858, the son of County Cavan immigrants John and Brigid (Farley) O'Connell and the youngest of the couple's eleven children, seven of whom were boys. The family had come to Lowell in 1853.

In the town of William O'Connell's boyhood, anti-Irish prejudice abounded as the number of new Irish made up nearly half the community's population within two years of his birth. He would describe the bias he and other Irish children endured in Lowell's public schools. According to O'Connell, many of his teachers spewed "bitter antipathy" toward their Irish pupils, and in one historian's words, O'Connell contended that "the Irish youngsters were made to feel inferior to Protestant children of English ancestry. And he complained that, when the teachers discussed the English Reformation, they portrayed the Protestant leaders—even the bloody Cromwell—as saints, while belittling the glorious name of Thomas More."

Like so many Irish immigrants, O'Connell's father toiled in a Lowell textile mill. He died in 1865, and William became utterly devoted to his widowed mother, who, as was the case with so many Irish mothers, wanted

Cardinal William O'Connell, the Boston prelate who wielded immense influence over the region's Catholics and the city's politics. *Courtesy of the Archdiocese of Boston.*

her youngest son to enter the priesthood and steered him to it. He embraced his mother's wish, the prejudice he perceived cementing his deep sense of being Irish and Catholic.

Following his years in the Lowell schools, O'Connell began his studies at St. Charles College, near Baltimore, in 1876, but he switched to Boston College to study under the Jesuits. In 1881, he graduated and asked for Boston Archbishop John Williams's help in launching his hope to become a priest. Williams agreed and sent the eager young Lowell man to the North American College in Rome, where O'Connell's religious studies commenced in earnest.

William O'Connell fell in love with Rome and with the Vatican, awed by both the power and opulence enjoyed by "princes of the church." After his ordination on June 7, 1884, he wanted to remain in Rome to study for a doctorate in divinity, but a family crisis prompted his return to Boston

and a subsequent appointment as an assistant pastor in Medford. Then, he was assigned to St. Joseph's Church in Boston's West End, where his stern eloquence won him renown as a voice of temperance and of church history.

In 1895, when a crisis of leadership erupted at the North American College, Archbishop Francesco Satolli, apostolic delegate to the United States, won selection of O'Connell as the school's new head. He impressed the cardinals with his intellectual and organizational acumen and caught the eye of Pope Leo XIII, who nominated O'Connell as the bishop of Portland, Maine, in 1897, despite a firestorm of protest by the clergy of Maine, who wanted "one of their own" instead of the Vatican-trained cleric. A meteoric rise was about to commence for William Henry O'Connell.

O'Connell flourished in his new post, strengthening and expanding parishes and working to smooth relations among the region's Catholics and Protestants. When his knack for diplomacy captured Rome's attention, he was sent in 1905 to Japan to scrutinize the chances for official relations between the Japanese court and the Vatican. His success delighted the Church hierarchy, and he was eventually rewarded with an appointment as coadjutor to his mentor, Archbishop Williams of Boston, with "right of succession" on William's retirement or death. Few, if any, priests in the region commanded the same influence in Rome as did O'Connell, and when Williams died in 1907, the forty-eight-year-old priest from Lowell became the archbishop of Boston. He was destined to dominate the Irish Catholic community throughout New England for decades to come and to extend his influence far beyond the boundaries of his church.

One of O'Connell's early moves came in 1908, with his outright purchase of the *Boston Pilot*. It served as another pulpit for his conservative, imperious polemics, and O'Connell laid down the canonical law for parishioners' lives in the church, in their businesses and in their homes. It was no exaggeration to state that for a few decades, the cardinal could sink or elevate the prospects of any Irish pol in the region. A sophisticated, brilliant man, he loved to travel overseas and did so frequently, his junkets earning him the nickname "Gangplank Bill" for the number of times newspaper photographers caught him coming down or going up a ship's gangplank.

O'Connell brought his bottom-line business perspicacity to the daily administration of the archdiocese, building and refurbishing churches, raising funds for foreign missions and exercising hands-on administrative control in a way that impressed and dismayed many powerful figures. His commitment to education resulted in new parochial schools and colleges, including Regis College for Women in 1927. O'Connell oversaw the

Cardinal O'Connell taking in a Red Sox game at Fenway Park. *Courtesy of the Archdiocese of Boston.*

establishment of uniform Catholic curricula in his schools and reshaped the key seminary in Brighton by dismissing the Sulpician Order and replacing it with his handpicked priests from the archdiocese.

On the layperson front, he ordained that chapters of the Holy Name Society be established in every parish. Similarly, he instituted an enhanced presence for the Catholic Women's League, which had been created to foster charitable and educational work.

In many ways, O'Connell's presence was imperial, historian David J. O'Brien writes: "The Archbishop's firm control and supervision of the work of his archdiocese expanded dramatically. His Catholic population rose from 750,000 to more than 1,000,000, making it the nation's third largest, the number of parishes increased from 194 to 322 and the number of secular priests more than doubled. By the start of World War II the diocese had 158 parish schools, 67 high schools, 7 Catholic hospitals, and 10 orphanages, plus a wide range of social and charitable institutions."

In his insistence on efficient administration, O'Connell did not hesitate to remove people he felt were not doing their jobs well, a fact that may have contributed to his reputation for having a cold personality. His

domination of the Church in Boston extended beyond the organizational centralization that marked his administration and reflected the more sophisticated approach to diocesan management that was to replace the flexible response of the earlier generation to the huge waves of immigration in the nineteenth century.

Once composed of outcasts from Ireland and Europe, the Catholic population during O'Connell's reign came to dominate the political life of Massachusetts. O'Connell's powerful oratory and overwhelming personality reflected the new self-confidence of the Catholic people. He believed that the time had come for the church and its members to come to the fore and take a proud and unapologetic stance in relation to their fellow citizens. A refined and cultural man, O'Connell was frequently disdainful of Irish American mores and critical of Catholic politicians like James Michael Curley.

Still, O'Connell never forgot the anti-Irish prejudices at which he had bristled in his youth. Throughout his reign, he harangued anyone who he believed was an anti-Catholic bigot.

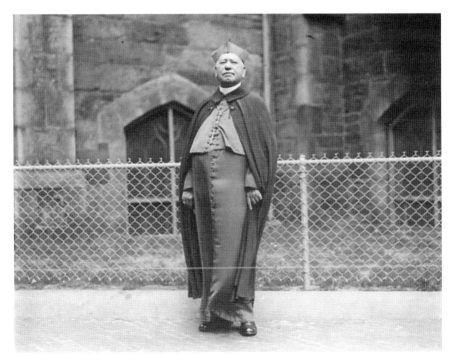

Cardinal O'Connell exuded an imperious and imposing demeanor. *Courtesy of the Archdiocese of Boston.*

In the 1930s, O'Connell, ever the son of a Lowell textile worker, supported the rights of unions but reviled any labor organizer he felt was pro-Communist, and he earned the ire of many Catholics when he railed against popular and controversial radio orator Father Charles E. Coughlin.

A bull of a man until his last few years, O'Connell came to rely on his auxiliaries, men like Richard Cushing, who became a bishop in 1939 and later succeeded the cardinal. In April 1944, O'Connell was felled by a cerebral hemorrhage and soon succumbed to the pneumonia that followed. He was laid to rest in the Chapel of the Blessed Virgin, a structure he had commissioned on the grounds of St. John's Seminary in Brighton.

From Lowell's "Acre," the mill city's tough and poor Irish neighborhood, to the halls of religious power, the son of County Cavan immigrants had completed a remarkable and controversial journey.

In recent years, a spate of books and articles have examined and illuminated the scandals that tarnished William O'Connoll's tenure as Archbishop of Boston. James O'Toole's book *Militant and Triumphant* contends that O'Connell was aware that several priests—one of them his nephew—were secretly married, and that the cardinal looked the other way on these and numerous other violations of church rules by his priests. Professor O'Toole describes O'Connell as a dictatorial "prince of the church" with little regard or respect for his parish priests.

A prime example of how devastating his wrath could be was his aforementioned decision in 1911 to expel the Sulpician Fathers, whom he had never liked, from his seminary and replace them with his acolytes.

The case of O'Connell's nephew remains one of the biggest blemishes and scandals of the cardinal's tenure, a classic case of nepotism. The nephew enjoyed a meteoric rise from lowly priest to monsignor and archdiocesan chancellor. His powerful uncle safeguarded the fact that the nephew was secretly married and that when he suddenly left the priesthood and moved to New York to set up a business, he did so with $750,000 of the archdiocese's money. O'Connell made sure that the news never got into print, a measure of how powerful his influence was in Boston.

Part VII

A PAPER, A POETESS, A PLAYBOY AND A PULITZER

SAVING THE *BOSTON PILOT*

John Boyle O'Reilly and Patrick Donahoe

I n 1876, John Boyle O'Reilly was a man on the rise in Boston's and the nation's literary and newspaper circles. A Fenian rebel who had first been sentenced to death by the Crown but transported instead to hard labor in western Australia, O'Reilly had escaped from the hellish confines of Fremantle Gaol aboard a New Bedford whaler. Now happily married and living in a stylish Charlestown brownstone, he had become both the star writer and editorial voice of the *Boston Pilot*. The newspaper had become the focal point of his professional and civic life.

When the *Pilot*'s publisher, Patrick Donahoe, O'Reilly's boss and earlier benefactor, lost most of his fortune in the Great Fire of 1872, the newspaper faced extinction. Donahoe was forced to declare bankruptcy. He was over $300,000 in debt and owed $73,000 of that sum to struggling Irish immigrants who had deposited funds in his failed Boston bank.

Well aware of Donahoe's predicament, O'Reilly was determined to find a way to save the paper. In January 1876, O'Reilly wrote to a friend that "there had been trouble around the office." He related: "Donahoe is bankrupt—in the worst way. Poor old man my heart grieves for him, and I have given all my wits to help him out. I think I have done so—in a way—the only way to save his honor."

O'Reilly waited until the *Pilot*'s fate was assigned to Charles Kendall, Charles Shepard and Patrick Collins. O'Reilly then presented a plan to purchase the newspaper, which bought him time from the trio. Shortly after meeting with them, O'Reilly visited Boston's Archbishop John J. Williams

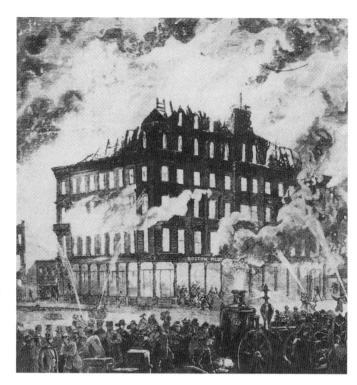

The Great Boston Fire destroyed a large swath of the city, including the *Boston Pilot* building. *Courtesy of the* Boston Pilot.

with an offer that the editor and the prelate buy the *Pilot* for $25,000 in cash and assume the newspaper plant's $65,000 mortgage. Williams would own three shares—or 75 percent—of the paper, and O'Reilly would hold one share, 25 percent.

On April 15, 1876, the archbishop and O'Reilly officially became the newspaper's owners. Meanwhile, O'Reilly's elation at rescuing the *Pilot* was tempered by his worry over a secret that only a handful of men knew: the New Bedford whaler *Catalpa* had anchored off western Australia, and a plan to free six of O'Reilly's fellow prisoners from the horrors of Fremantle Gaol and forced labor in Australian quarries and bush country was nearing its climax. O'Reilly, along with the future "father of the IRA," John Devoy, had played a key role in procuring the *Catalpa* and in introducing his fellow plotters to the New Bedford men who helped to launch the mission—literally.

The whaler rescued the six Irish prisoners two days later, on April 17, and the *Pilot* was one of the first newspapers in the world to break the stunning news of the plot's success, an event that was always to fill O'Reilly with pride for a blow struck against his former captors.

Left: Irish immigrant Patrick Donahoe's rags-to-riches saga literally went up in the flames of the Great Boston Fire. *Courtesy of the* Boston Pilot.

Below: John Boyle O'Reilly helped save the *Boston Pilot* and boss and friend Patrick Donahue from ruin. *Courtesy of Burns Library, Boston College.*

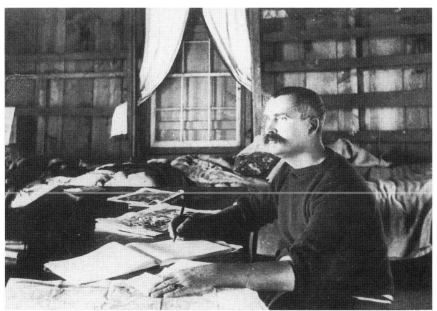

Although the *Pilot* would one day become the archdiocese's official paper, with O'Reilly at the helm and Williams taking a silent role, the publication was considered an "Irish newspaper." Still, as historian A.G. Evans notes, "it was also the diocesan paper serving all Catholics of whatever nationality, and Williams trusted O'Reilly's editorial judgement completely because there is no hint of disagreement in any of the routine correspondence between them, nor a record of obstruction to the editor from on high. O'Reilly seemed to have had a free hand not only in editorial matters, but also in day-to-day management and the hiring of staff.

"Under the new proprietors the *Pilot* entered upon a halcyon period of its history."

O'Reilly wrote on a wide array of topics, including his advocacy of equal rights for African Americans, his diatribes against anti-Semitism and his espousal of better treatment of all immigrants. He also made the *Pilot* an outlet in which some of the era's finest female writers and poets could have their work regularly published.

His liberal views on many social and cultural issues notwithstanding, O'Reilly proved a conservative Catholic with traditional views of men's and women's roles in the Church and in the household.

"YOU ARE ONE OF THE BIRDS THAT MUST SING"

Mary McGrath Blake

In the 1880s, the very idea of "working moms" made society bristle with indignation or suspicion. "Proper women" married and raised families. A Boston Irish woman, however, belied that stricture, challenging the social status quo. Her name was Mary Elizabeth Blake, and her professional achievements outside her marriage earned her the grudging praise of James B. Cullen, a prominent writer and historian of the day: "Mrs. Blake's well-ordered and happy home is a standing refutation of the absurd old notions that a woman of letters is of necessity a failure in the higher office of wife and mother."

Born in the bustling town of Dungarvan, County Waterford, in 1840, Mary Elizabeth McGrath boarded a passenger ship with her parents to escape famine-wracked Ireland in 1849. Unlike so many of the desperate famine Irish who sought new lives in and around Boston from 1845 to 1850, the McGraths' prospects for success were good, despite the rampant, entrenched prejudice against the Irish. Her father was not only a well-educated man and a voracious reader but also a skilled and ambitious mason and stonecutter. He settled his family just south of Boston in Quincy, whose quarries provided the literal building blocks for Boston's homes, public buildings, churches and public-works projects.

Within a few years, her father was his own boss, opening the McGrath Marble Works, which brought the family success and local status and provided jobs for fellow Irish immigrants. Mary, imbued with her father's

love of literature, breezed through Quincy High School and, thanks to her father's wealth, continued her education in Boston at George Emerson's private school, a pricey finishing school for daughters of privilege. She was one of the academy's few students who did not come from genteel Brahmin families able to trace their lineage back to Massachusetts's founders.

Mary McGrath's education did not stop with Emerson. For several years, she studied music, languages and literature at the prestigious Academy of the Sacred Heart in Manhattanville, New York. She had also started to garner literary attention as a teen, a precocious talent that led Cullen to laud "her graceful poems and sketches, [she] contributed to *The Pilot* [newspaper] over the pen name of 'Marie,' [which] attracted much favorable notice." Her work so enthralled P.B. Shillaber, the esteemed editor of the *Boston Gazette*, that he soon "secured her promising pen."

In 1865, she married Dr. John G. Blake, of Boston, and the couple would have eleven children, leaving one to wonder how she managed to find the time to pursue her writing career. As "Marie of *The Pilot*," her popularity as an essayist and poet spread her renown far beyond Boston. Locally, her work appeared regularly in an array of other newspapers and magazines, including the *Boston Gazette* and the *Boston Transcript*. In the pages of the *Boston Journal*, Her "Rambling Talks" proved a must-read for a wide audience.

No one would have mistaken Blake as a suffragette. Her writing espoused traditional tenets of domestic life and her conservative Catholicism and politics, with two notable exceptions: her career outside hearth and home as a writer and poetess, and her unabashed pride in her Irish heritage. Oliver Wendell Holmes was so impressed by her talent that he told her, "You are one of the birds that must sing."

In articles, columns, poems and several books, Blake wrote on everything from her trips across America to her sojourns to Europe with her children. Her heartrending poem "In Sorrow," about the loss of three children in the space of a week, captured the emotions of readers who had suffered the same anguish.

She became an ardent pacifist for the American Peace Society and penned *The Coming Reform: A Woman's Word*. A diatribe against "the absurdities of old fashioned militarism at home and abroad," her pamphlet was published amid the jingoism of the Spanish-American War, in 1898. Theodore Roosevelt, who literally rode into near-mythic status at the head of the Rough Riders in that conflict, reportedly remained an admirer of Blake despite her view of the war.

U.S. Supreme Court justice Oliver Wendell Holmes Jr. admired the poetry of Boston Irish writer Mary McGrath Blake. *Courtesy of Library of Congress.*

Blake passed away in Boston in 1907. As James B. Cullen notes, one of her poems continued as a favorite at Irish patriotic festivals and was reproduced hundreds of times in Irish publications. She called it "Our Record":

Who casts a slur on Irish worth, a stain on Irish fame?
Who dreads to own his Irish blood, or wear his Irish name?
Who scorns the warmth of Irish hearts, the clasp of Irish hands?
Let us but raise the veil to-night and shame him as he stands.

The Irish fame! It rests enshrined within its own proud light,
Wherever sword, or tongue, or pen has fashioned deed of might;
From battle-charge of Fontenoy to Grattan's thunder tone,
It holds its storied past on high, unrivaled and alone.

A RIOTOUS OPENING NIGHT

J.M. Synge's Playboy *Hits the Hub*

In October 1911, *The Playboy of the Western World* hit Boston. The city's Irish wards had all heard about the furor that J.M. Synge's controversial play had ignited throughout its premier performances at the Abbey Theatre in Dublin. The riots erupting in the playhouse had taken place some four years earlier, but many in Boston wondered if the local Irish would similarly howl at Synge's "obscene language" and "denigration" of rural Ireland. Others mulled whether the Boston Irish would embrace the work as the watershed masterpiece it was for the blossoming Irish National Theatre.

Leading the Irish Players of the Abbey Theatre into Boston were none other than William Butler Yeats and Lady Gregory, who had helped found Ireland's National Theatre and who had nurtured a talented, sickly writer named John Millington Synge. The playwright had not lived long enough to see his "Playboy on the boards of the American stage." Yeats arrived in Boston first, viewing the company's production of such plays as Synge's *In the Shadow of the Glen* and *The Well of the Saints*, as well as several other works. The big night, however, was to be October 16, 1911, when *The Playboy of the Western World* would make its American debut on the boards of the Plymouth Theatre's stage, also known as the "New Plymouth," which had been designed by noted architect C.H. Black.

On that evening, Synge's characters "Christy Mahon," "Pageen Mike" and company would hold sway at the spacious theater on Stuart Street

Left: Theater playbill for John Millington Synge's incendiary *The Playboy of the Western World*. *Courtesy of the Boston Public Library*.

Right: The Plymouth Theatre was the stage for the Boston premier of Synge's *The Playboy of the Western World*. *Courtesy of the Boston Public Library*.

near Tremont (close to the present-day Emerson Majestic Theater). The Plymouth later earned the praise of theater critic Elliot Norton as "one of the crucibles of the American drama" because of the numerous works that were staged there. *The Playboy of the Western World* was the production that first gave the Plymouth that reputation.

Lady Gregory wrote of her arrival and the mounting excitement as October 16 approached. "Mr. Yeats, who had gone on with the Company, came to meet me on board ship as we arrived at Boston on September 29th, St. Michael's Day, and told me of the success of the first performances there, and that evening I went to the Plymouth Theatre and found a large audience, and a very enthusiastic one, listening to the plays. I could not but feel moved when I saw this, and remembered our small beginnings and the years of effort and of discouragement."

It was fitting that Boston served as the initial U.S. venue for the play that had filled Hibernia with howls and hisses in 1907. The pronounced presence of the Irish greeted the Abbey's players from the moment they alighted from their steamer's gangplank and stepped onto the city's waterfront. Along the

wharves, burly dockworkers shouted in thick brogues or gentler lilts that marked the men as formerly of the "old sod."

For Lady Gregory, Boston felt both fascinating and familiar as she bustled about in the run-up to the landmark night.

> *I had plenty to do. at first I had not much time to go about, for I rehearsed all the mornings, but when I got free of constant rehearsal I was taken by friends to see, as I longed to see, something of the country. I wanted especially to know what the coast here was like—whether it was very different from our own of Galway and of Clare, and I had a wonderful Sunday at a fine country house on the North Shore and saw the islands and the reddish rocks, and like our grey ones opposite and the lively tints of the autumn leaves, a red and yellow undergrowth among the dark green trees. Boston is a very friendly place. There are so many Irish there that I had been told at home there is a part of it called Galway, and I met many old friends. Some I had known as children, sons of tenants and daughters, now comfortably settled in their own houses. I had known of the nearness of America before I came, for I remember asking an old woman at Kiltartan why her daughter who had been home in a visit had left her again, and she had said, "Ah, her teeth were troubling her and her dentist lives at Boston."*

A troubling development for Lady Gregory, Yeats and the Irish Players lay in rumors that the local Irish would protest or even riot at the *Playboy*'s premiere. To protect the troupe, the theater company hired a group of burly athletes from Harvard to stand guard at the Plymouth premier.

Alternately nervous and excited, Lady Gregory wrote in an October 8, 1911 letter:

> *I send a paper with opinions for and against the plays. I am afraid there may be demonstrations against Harvard and The Playboy. The Liebler people* [the show's backers] *don't mind, think it will be an advertisement. I was cheered by a visit from some members of the Gaelic League, saying they were on our side and asking me to an entertainment next Sunday, and from D.K., who is very religious and wants to go into a convent. Yeats leaves for New York today, but comes back for first night of "The Playboy" next Monday and sails Tuesday. They are rather afraid of trouble, but I think the less controversy the better now. It should be left between the management and the audience.*

A Paper, a Poetess, a Playboy and a Pulitzer

The manager says we may stay longer in Boston, we are doing so well. I should like to stay on. It is a homey sort of place. I am sent quantities of flowers, my room is full of roses and carnations.

She wrote a few days later:

Now as to the trouble over The Playboy. We were told, when we arrived, that opposition was being organized from Dublin, and I was told there had already been some attacks in a Jesuit paper, America. But the first I saw was a letter in the Boston Post of October 4ᵗʰ, the writer of which did not wait for "The Playboy" to appear but attacked plays already given. Birthright and Hyacinth, Halvey. The letter was headed in large type. Dr. J.T. Gallagher denounces the Irish plays, say they are Vulgar, unnatural, Anti-natural, Anti-National, and Anti-Christian. The writer declared himself astonished at "the parrot like praise of the dramatic critics." He himself had seen these two plays and [wrote] "my soul cried out for a thousand tongues to voice my unutterable horror and disgust.....I never saw anything as vulgar, vile, beastly, and unnatural so calculated to calumniate, degrade and defame a people and all they hold sacred and dear."

On October 16, 1911, the press and theatergoers streamed through the doors of the Plymouth Theatre and waited, not exactly sure what would unfold. The Boston Police also waited in and around the building.

The *Gaelic American* had weighed in two days earlier, on October 14, before the first words of Synge's *Playboy* even pealed through the Boston playhouse.

Irishmen Will Stamp Out the Playboy—Resolved—That we, the United Irish American Society of New York, make every reasonable effort through a committee, to induce those responsible for the presentation of "The Playboy" to withdraw it, and failing in this pledge ourselves as one man to use every means in our power to drive the vile thing from the stage, as we drove McFadden's Row of Flats and the abomination produced by the Russell Brothers, and we ask the aid in this work of every decent Irish man and woman, and of the Catholic Church, whose doctrines and devotional practices are held up in scorn and ridicule in Synge's monstrosity.

On hand to observe the potential "monstrosity" was William A. Leahy, the secretary to Boston mayor John F. "Honey Fitz" Fitzgerald and the censor for the Police Commissioner, the latter official holding the power to

Editorial cartoon lampooning *Playboy* protesters. *Courtesy of the National Library Newspaper Archives, Dublin.*

Irish actors Sara Allgood and J.M. Kerrigan appeared with *The Playboy of the Western World* in Boston as potential riots loomed. *Courtesy of Boston Public Library.*

close down the production if he deemed it "obscene." Leahy had seen the Irish Players' other productions at the Plymouth: "I have seen the plays and admire them immensely. They are most artistic, wonderfully acted, and to my mind absolutely inoffensive to the patriotic Irishman. I regret the sensitiveness that makes certain men censure them knowing what Mr. Yeats and Lady Gregory want to do, I cannot but hope that they succeed and that they are loyally supported in America. My commendation cannot be expressed too forcibly."

What remained to be seen was how "forcibly" the Boston Irish responded to *The Playboy of the Western World.* On October 16, 1911, the answer would unfold—memorably so.

According to the Abbey Theatre's archivist, "The play was an instant success, and the audience enthusiastic. Owing to condemnatory resolutions passed by a number of Irish societies, there was some booing in the gallery, but the booers were ejected. Reviews of the Playboy were universally laudatory. The Abbey Company's Boston engagement had been so successful that the season had been extended for a fortnight."

Mayor John F. Fitzgerald ("Honey Fitz") came to the performance to welcome Yeats and, according to the *Boston Sunday Post*, was so enthused he neglected important engagements and remained through the entire evening, applauding until he split his gloves.

HOME OF *THE LAST HURRAH*

Literary Magic in a Back Bay Brownstone

I n the early 1950s, the lights stayed on late in the evening at a brownstone apartment on Marlborough Street. Novelist Edwin O'Connor was hard at work in his modest flat, the furniture his landlord's, writing a masterpiece that would forever capture the final campaign of a fictional politician named Frank Skeffington. Skeffington was actually the thinly disguised counterpart of "Himself"—James Michael Curley. Entitled *The Last Hurrah*, O'Connor's work would be acclaimed in many circles as the finest American political novel.

"I wanted to do a novel on the whole Irish-American business," O'Connor said. "What the Irish got in America, they got through politics, so, of course, I had to use a political framework." In Boston, he found his theme.

The son of a doctor and a schoolteacher, both of them Irish American, Edwin O'Connor was born in Providence, Rhode Island, in 1918. Raised in Woonsocket, he would later write, "To see it is not to love it."

He went on to Notre Dame, intending to study journalism. But one of his professors opined, "You can learn all you need to know about journalism in six months. English literature takes a little longer." His imagination charged, O'Connor switched his major to literature.

He arrived in Boston after his graduation, full of plans to write novels. He was working for a pittance as a reviewer for the *Boston Herald* in the early 1950s. Catching the eye of Edward Weeks, the editor of the *Atlantic*, O'Connor was hired by him to edit radio great Fred Allen's memoir, *Treadmill to Oblivion*, in 1953, and began a lifelong relationship with the

Left: 10 Marlborough Street, where Edwin O'Connor crafted his magnificent Boston Irish political novel *The Last Hurrah*. *Photo by Peter F. Stevens.*

Right: Author Edwin O'Connor, whose Irish American themes earned him a Pulitzer Prize. *Courtesy of the Boston Public Library.*

magazine. Another *Atlantic* editor, Robert Manning, wrote that the magazine was O'Connor's "club" on Arlington Street, the place where he would drop in when "a few steps from our door."

O'Connor, who had also worked as a radio announcer and producer in Boston, was noted by literary critics as a man who possessed an "ability to write with his ears." As O'Connor labored on Marlborough Street on *The Last Hurrah*, his keen ear for dialogue gave voice to Skeffington and other unforgettable characters. A reviewer wrote: "I find myself remembering… its [*The Last Hurrah*'s] talk, its spate of wild, outrageous talk cascading down every page."

When *The Last Hurrah* was published in 1956, it shot to the top of the nation's bestseller list, catapulting O'Connor to fame and financial success. Still, not all reviewers embraced his portrait of Curley/Skeffington. A writer for the *New Yorker* contended that O'Connor had polished up the "barbaric" Boston politician into a "fairy godmother of widows and orphans" and had turned "vices into virtues." Despite the naysayers, the novel proved an immense hit, as most readers concurred with the *New York Times*'s assessment

of O'Connor's work. "[He] has no doubts about what Skeffington cost the city or the Irish.…He also makes it clear, however, that the tragedy is collective, the failure…to have the courage of [one's] won qualities and to make better use of them."

Less than two years after the novel's publication, O'Connor's book received the big-screen treatment, with Spencer Tracy playing Skeffington.

Following the success of the novel, O'Connor never moved far from the furnished apartment where he had crafted Skeffington and company, nor did the author move far from his "home away from home," the *Atlantic*. Shaun O'Connell notes: "After *The Last Hurrah* became a financial and critical success, O'Connor moved, but not far from the center city of his imagination. In Boston he always lived within the elegant circle of Beacon Hill and Back Bay: on Beacon Street, then on Chestnut Street, finally back on Marlborough Street, where he bought a mansion across from his old rooming house. Throughout these moves, he came to *The Atlantic* daily, full of wit and charm."

Editor Robert Manning recalled of O'Connor: "He would deliver a marvelous story with a mimicry that was devastating but never unkind, or shift his big frame into a brief soft-shoe to the humming of 'Keep working America.'"

In the assessment of author Shaun O'Connell: "Edwin O'Connor's fiction stands as his oblique spiritual autobiography: the discovery of his true subject—the record of his own kind and the story of their religious and political seizure of a city—and his renunciation of the city which seized his Irish-Americans: Boston. Like other writers before him O'Connor was both inspired and disappointed by the city upon a hill, but he took to heart its lasting lesson: the need to quest for spiritual transcendence."

In 1962, O'Connor won the Pulitzer Prize for fiction with his work *The Edge of Sadness*. The novel, rendered through the eyes of an aging, reformed alcoholic priest named Hugh Kennedy, presents the saga of the Carmody family over three generations. The clan's resemblance to the real Kennedy family is unmistakable. A *New York Times* reviewer asserted that the Pulitzer Prize went to the "right writer—if for the wrong book." The book he liked better was *The Last Hurrah*, written in a Marlborough Street flat. It gave more than a fleeting glance to the building where Edwin O'Connor crafted one of the best political novels in American literature.

Part VIII

REBELS, PATRIOTS AND REPROBATES

"He Might Have Known Better"

Patrick Carr

A t first glance, one might think that thirty-year-old Patrick Carr stands as a classic case of being in the wrong place at the wrong time. After all, the Irish immigrant was felled by a redcoat's musket ball during the Boston Massacre on the frigid, snow-shrouded evening of March 5, 1770. Carr, however, chose to be there. In fact, he had intended to carry a concealed sword.

Much of what is known about the tragic arc of Carr's life from Ireland to Boston comes from the trial records of the British soldiers tried for killing five colonists scant feet away from the red-brick walls of the town's Old State House, from the records of King's Chapel and from the research of historian J.L. Bell. The accused were defended by local attorney John Adams, who, despite his staunch opposition to British suppression of colonists' rights, stood up for the right of the accused to a fair trial. His skilled, reasoned arguments convinced a jury of Bostonians to acquit. Of the victims, Carr was the last to die, lingering until March 14, 1770.

Patrick Carr was born around 1740 in Ireland. The details of his life prior to his immigration to Boston are few, and if his religion was Catholic, he could not have practiced it openly. As with a handful of Irish in the town, he might well have "joined" one of the region's Protestant meetinghouses or churches. He was a skilled leather worker, and as with many tradesmen of the era, he lived at the house of his employer, "Mr. [John] Field, Leather-breeches Maker and Glover." Field, who would join the Charitable Irish Society of Boston in 1772, was likely Irish, too, as the group was mainly composed of merchants with some tie to Ireland.

According to Boston surgeon Dr. John Jeffries, Carr "was a native of Ireland, that he has frequently seen mobs, and soldiers called upon to quell them: whenever he mentioned that, he always called himself a fool, that he might have known better, that he had seen soldiers often fire on the people in Ireland, but had never seen them bear half so much before they fired in his life."

Carr uttered those words as he lay dying from a British round that had "entered near his Hip, and went out at his Side." His thoughts reveal that perhaps his experiences with British oppression in Ireland drove him to join the Boston throng confronting redcoats near the Old State House on March 5, 1770. Like many in town, Carr viewed the troops as an occupation force suppressing colonists' rights. Perhaps, too, his words reflected that he should have "known better" than to take that risk.

On the evening of March 5, Carr was in his quarters at Field's house, "on Prison Lane," the west end of Queen Street, which was close to the Old State House. Suddenly, church and fire bells pealed, and shouts from a crowd erupted a block away. Carr grabbed a sword he intended to conceal under his coat and started for the door. Field and his wife pleaded with Carr to leave the weapon behind, "but only an unnamed neighbor woman was able to convince Carr to leave that weapon behind."

Carr headed out the door and made his way through the icy streets to a throng berating and pushing toward a line of nervous soldiers. As he neared the mob on King Street, a shot crackled above the cobblestones. Other redcoats opened fire as screams and curses rose and protesters and onlookers scattered in all directions. Men crumpled to the street, four dead—including Crispus Attucks, a free Black man—and at least ten wounded. A musket ball slammed into Carr's hip. He, too, toppled, writhing in the snow. Several friends grabbed his arms and legs, tried to stanch the heavy bleeding and, struggling to stay upright on the icy stones, carried him to the Fields' home.

Field immediately summoned Dr. Jeffries. When the surgeon arrived, he stabilized the groaning Irishman but had little hope that Carr would survive. Several other doctors arrived at the same prognosis. For nine days, Carr languished. Then, on March 14, he succumbed, the fifth to die in the Boston Massacre.

Ironically, Carr, an Irishman in a town with little love of that country, received a hero's sendoff, as had the other four victims of the clash. A massive crowd accompanied his coffin to the Old Granary Burial Ground.

Months after the Boston Massacre, two trials unfolded. First came that of Captain Thomas Preston, in command of the "Regulars" on that brutal March evening. Next was that of eight of his soldiers. Preston and six of his

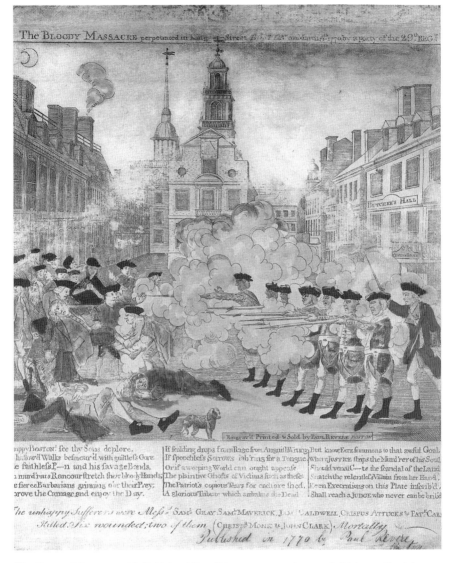

The Boston Massacre, with British soldiers firing on an unruly crowd. Irishman Patrick Carr fell mortally wounded. *Courtesy of Library of Congress.*

men were acquitted; two others were convicted of manslaughter. Accounts vary as to whether the first shot, which ignited those that followed, was intentional or caused by a soldier slipping and firing accidentally.

The trials' key witness proved none other than Dr. Jeffries, the surgeon who had tended to Patrick Carr. Testifying that he and Carr had talked at

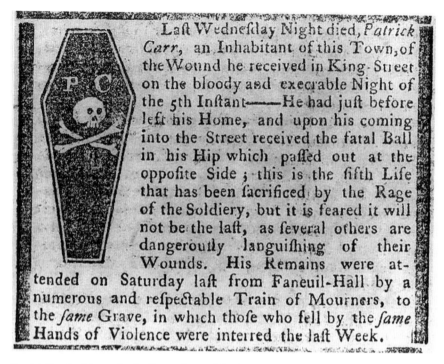

Laft Wednefday Night died, *Patrick Carr*, an Inhabitant of this Town, of the Wound he received in King-Street on the bloody and execrable Night of the 5th Inftant——He had juft before left his Home, and upon his coming into the Street received the fatal Ball in his Hip which paffed out at the oppofite Side; this is the fifth Life that has been facrificed by the Rage of the Soldiery, but it is feared it will not be the laft, as feveral others are dangeroufly languifhing of their Wounds. His Remains were attended on Saturday laft from Faneuil-Hall by a numerous and refpectable Train of Mourners, to the *fame* Grave, in which thofe who fell by the *fame* Hands of Violence were interred the laft Week.

Patrick Carr's obituary in the *Boston Gazette*, March 19, 1770. *Boston Gazette, and Country Journal. Courtesy of Boston Public Library Newspaper Archives.*

great length before the Irishman died, Jeffries asserted that Carr believed the soldiers had opened up on the crowd in self-defense.

"I asked him [Carr] whether he thought the soldiers would have been hurt, if they had not fired. He said he really thought they would, for he heard many voices cry out, 'kill them.'"

In 1888, a soaring monument was erected on Boston Common to commemorate the five men slain on March 5, 1770. Despite objections from many prominent locals to the idea of honoring an African American (Attucks) and an Irishman (Carr), the project went through and soon became known as the Boston Massacre Monument or the Crispus Attucks Monument. The driving force behind it was the *Boston Pilot*'s John Boyle O'Reilly, an Irish rebel against the British Crown and a champion of immigrants and African Americans in an era when prejudice against both was vitriolic and rampant. At the monument's dedication, he delivered an eloquent and impassioned address on the diversity of those five martyrs.

CAPTAIN MALCOLM
TAKES ON THE CROWN

A Merchant's Mettle

In 1765, Captain Daniel Malcolm's "Irish temper" was up. According to the historian James B. Cullen, red-coated troops on Boston's cobblestones and dirt paths muttered the words "rebel" at Malcolm and other Boston merchants. In response came growls of "tyranny" from colonists.

Exacerbating tensions, the frigate HMS *Romney* and other warships swayed at anchor in Boston Harbor. Malcolm and fellow merchants sensed that customs officials and the Royal Navy intended to make an example of any colonist bucking import fees or concealing contraband. Malcolm was about to become that example—along with a prominent and wealthy entrepreneur named John Hancock.

The simmering tensions boiled over on June 10, 1768, when the sloop *Liberty*, owned by Hancock, slid into Boston Harbor and docked at Hancock's wharf (later Lewis Wharf) with a load of wines from Madeira, Spain. Shortly after the merchantman moored, a customs official, or "tidewaiter," as his trade was called, Thomas Kirk, strode aboard the *Liberty*, sat with the ship's master in his cabin to sip rum punch with him and waited for the crew to offload the sloop's cargo. Then, as was the practice with all incoming cargo, the tidewaiter intended to inventory the goods and tally the port duties owed by the ship's owner.

Port officials had long allowed colonial merchants to declare only a portion of imported goods and to unload the rest of the cargoes without duty payments. The Crown, however, had ordered customs officials to halt the practice and charge fees on all imported goods.

Hancock had no intention of paying the duty. He had ordered the *Liberty*'s captain to hold the official captive until the wine had been unloaded and removed from the docks. At about 9:00 p.m., the sputtering customs official was restrained for what would turn into hours. He was not released until the cargo was long gone.

Historian James B. Cullen writes: "Though the rumbling of the carts and the wakefulness of these troubled times made concealment impossible, the removal was not interfered with. A guard of thirty or forty strapping fellows bearing clubs marched with the loaded carts, and may have had something to do with the forbearance of the officials. The next day Captain Barnard, master of the sloop, made entry of five pipes of wine, as his whole cargo, and then there was trouble."

Hancock had flung the gauntlet at the Crown. Now, he, other merchants such as Malcolm and all of Boston awaited the authorities' next move. They did not have to wait long.

A pair of customs officers, Collector Joseph Harrison and Comptroller Joseph Harrison, as well as Comptroller Benjamin Hallowell, strode aboard the sloop the next day and seized it for "violation of the revenue laws." As word spread along the docks, a throng of outraged colonists gathered alongside the *Liberty*, Captain Daniel Malcolm quickly taking the lead.

The crew's anger soared as Hallowell, according to Cullen, "marked the vessel with the broad arrow [a painted sign that it had been impounded] and signaled to the warship *Romney* as she lay anchored in the stream."

The *Romney*'s commander, Captain Comer, dispatched longboats manned by armed sailors and Royal marines with orders to tow the *Liberty* from the dock, at which the frigate's cannons were aimed.

As the boats neared the wharf, the crowd surged, with Malcom standing alongside the sloop and shouting his protests. Cullen notes: "Malcom said [the *Liberty*] was safe where she was, and no officer nor anybody else had a right to remove her. The boats arrived, and the excitement increased. Malcolm and the other leaders of the populace threatened to go on board and throw the frigate's people into the sea. Suddenly the sloop's moorings were out, and before anything could be done to prevent it she was gone from the wharf."

Famed nineteenth-century historian and Secretary of the Navy George Bancroft rendered a saltier version of the encounter at the dock.

> *"You had better let the vessel be at the wharf," said Malcom.*
> *"I shall not," said Hallowell, and gave directions to cut the fasts.*

"We will throw the people from the Romney overboard," said Malcolm, stung with anger.

With the Royal marines poised to fire, Malcolm and company could do little more than yell. Bancroft writes, "So they [the British] sailors cut her [the *Liberty*'s] moorings, and with ropes in the barges the sloop was towed away to the *Romney*."

As the customs officials foolishly waded into the crowd rather than leave in one of the *Romney*'s longboats, the mob followed them, roughed them up, broke the windows of Hallowell's house and seized a customs official's longboat. Malcom and the others dragged it to the Common, smashed it to pieces and set the wreckage ablaze. The two officials fled to Castle William, fortunate to be alive.

Order was restored in the following days, but the tensions would percolate inexorably in the coming years, pushing ever closer to revolt against the Crown. Captain Malcolm, so prominent a figure in the *Liberty* affair, was appointed to various committees attempting to work with the authorities to resolve trade and customs issues. Cullen writes, "Malcolm's fellow citizens

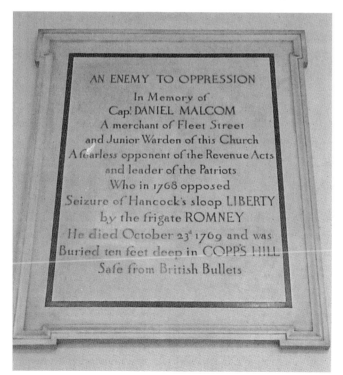

Tablet placed at Boston's Old North Church in honor of parishioner and anti-Crown firebrand Captain Daniel Malcolm. *Photo by Peter F. Stevens.*

appreciated him, and showed their confidence by selecting him as their representative in the troublesome and dangerous crisis in which he was an actor, but there is every reason to believe that his proper sphere was not diplomacy, but active and aggressive resistance."

Captain Daniel Malcolm would not have the opportunity to stand with Sam Adams, John Adams, Hancock and the other future rebels against King George III. The Irishman died in October 1769, some six years before "the shot heard round the world."

His gravestone on Copp's Hill still bears vivid testimony to his pivotal role in the early events that would fuel the American Revolution. Cullen writes: "The stone over it [Malcolm's grave]…is of hard blue slate, two inches thick, and showing about a yard above the ground. The inscription is a just statement of the merits and reputation, but an additional wreath is added to his laurels by the vindictive bullet marks of the British soldiery, who used this stone as a target, and peppered the gravestone of the man who feared nothing less than a British 'bloody-back.'"

"FIRE AND BE DAMNED!"

Captain Jeremiah O'Brien

C aptain Jeremiah O'Brien is a man worth remembering. Several years ago, a letter to the *Boston Irish Reporter* correctly noted that a local memorial to O'Brien deserves a spot among Boston's overlooked Irish sites.

The letter writer, Lenahan O'Connell, states: "The story about Captain Jeremiah O'Brien is enclosed herewith, entitled Tribute to Captain Jeremiah O'Brien addressed by my father Joseph F. O'Connell."

The saga is one well worth recalling.

On June 12, 1937, Boston's Joseph O'Connell, a former congressman, delivered a commemorative address in the State House's Hall of Flags. His speech, which marked the unveiling of a tablet honoring Captain Jeremiah O'Brien, would be printed in the U.S. Congressional Record of July 22, 1937.

O'Connell's words brimmed with pride at the heroic contributions of local patriots with Irish bloodlines. He began:

> *Massachusetts has determined that, in the march of time, the achievements of her heroes shall not be lost in the oblivion of the past, and today dedicates in enduring bronze this tablet to the memory of Captain Jeremiah O'Brien, a Massachusetts naval hero of the Revolution, who won the first battle of the sea, on June 12, 1775; who captured the first enemy flag in battle on either land or sea; and who was the first naval commissioned officer and commander in chief of the Navy of Massachusetts in the war for independence and of the Revolution.*

Miniature portrait of Captain Jeremiah O'Brien, whose seagoing skill and daring bedeviled the British during the Revolutionary War. *Courtesy of Library of Congress.*

Jeremiah O'Brien's story begins with the emigration of his father, Maurice O'Brien, from Ireland to Boston in the 1700s. According to several histories, Maurice fled to the colonies because of his rebel actions against the British, but he found a similarly hostile reception in Boston for himself and his "six sturdy sons." Jeremiah was the oldest of them.

Eventually, they moved to Machias, Maine (a part of Massachusetts at that time). O'Connell said, "In the course of years Maurice O'Brien joined a group that settled in Machias, which soon became an active and growing community. They were sturdy men, who were ready and able to hew out of the wilderness an abode for themselves."

As the Revolution loomed ever closer in the early 1770s, the O'Briens eagerly joined the rebel cause. Their sentiments little surprised those who knew them, noted O'Connell: "The family of Maurice O'Brien became famous and have filled a large space in the maritime history of the struggle for liberty—indeed, few, if any American families of the Revolutionary period can approach it....The moment the news of the outbreak of the Revolution reached the little frontier settlement of Machias, none were more earnest and fearlessly outspoken, in protesting against the increasing tyranny of the British Government than Maurice O'Brien and...sons.

"Maurice O'Brien had imbued his sons with his anger at Britain....Among the effects which Maurice O'Brien brought from Ireland to this country was an old portrait of Brian Boru, one of Ireland's ancient hero kings, who defeated the Danes in the Battle of Clontarf, driving them out of Ireland. This portrait was cherished by him and is still a treasured memento and with its motto, which translated, means 'Strength from Above.' In this way may be easily discerned the reason for the courage and faith that possessed him and his sons in their struggle for liberty. It was in their blood."

The O'Briens' collective blood was up by June 1775, as the news of Lexington and Concord had stoked the Machias men into action. The family had castigated British dominance and the Crown's tax on stamps and duties on tea and other imported goods for years. Then, in early June 1775, well-known Boston Tory Ichabod Jones dispatched two vessels, the

Unity and the *Polly*, to Machias to haul back lumber for the redcoats in Boston. The O'Briens and their patriot neighbors seethed at the sight of the merchantmen. It was the ships' escort, though, that prodded the locals into open rebellion.

Accompanying Jones's vessels was the Royal Navy schooner *Margaretta*, whose commander was an officer named James Moore, a nephew of High Admiral Thomas Graves of the Royal Fleet in Boston.

Jones himself informed the people of Machias that he would trade only with fellow Tories and ordered the locals to tear down their "Liberty Pole." With Moore threatening to fire on the town if they failed to comply, the area's patriots gathered to debate their next step.

With old Irish rebel Maurice O'Brien and his sons in the forefront, the locals chose to resist. O'Connell's speech describes the volatile atmosphere in Machias:

> *The Liberty Pole was guarded. The town leaders were the beloved parson, John Lyons; the aged warrior, Ben Foster; an old Quaker, David Gardner; and the doughty Maurice O'Brien. The air was charged with danger; but two days passed with threats and talk, and then came Sunday with all at church, including the British naval officer. The sermon was pungent, and John O'Brien was found seated behind Moore, gun in hand, ready for any trickery. Commander Moore fled on his schooner and sailed down the river, leaving a stern warning that the pole must come down or he would return. Jeremiah O'Brien, sensing trouble, had sent as far as Jonesport for ammunition.*

Near dawn on June 12, 1775, thirty-one-year-old Jeremiah O'Brien led a band of grim-faced Patriots aboard the Tory merchantmen and unloaded their lumber to the vitriolic protests of Ichabod Jones. O'Brien then called for volunteers to help him man one of the ships and attack the *Margaretta*, which was under sail and fleeing the scene. O'Brien and his makeshift crew set off in pursuit of the Royal Navy schooner, their arms "about 20 old muskets, a dozen pitchforks, and some axes, and scanty provisions." At his side were his five brothers: Gideon, John, William, Denis and sixteen-year-old Joseph, who had sneaked on board to his brothers' mixed ire and pride.

The Patriots began gaining on the schooner, and as they drew within shouting distance, Moore ordered O'Brien to sail away or else the British would open fire.

Jeremiah O'Brien allegedly retorted, "Fire and be damned!"

He rammed his vessel straight into the *Margaretta*, whose crew hurled grenades at their attackers. Explosions and musketry rent the air, and two rebels, named McNeill and Colbroth, died in the melee. At least seven of their comrades were wounded. Despite the losses, O'Brien and his surviving men swarmed aboard the British vessel, swinging their muskets and overwhelming the British. Moore, wounded, toppled to the blood-stained deck as the Patriots seized his ship. Four of his men lay dead. He would join them the following day.

Awash in the adrenaline of his deed, Jeremiah O'Brien sailed back to Machias with his trophy, the *Margaretta*. Counseled by Maurice, he soon realized that the Royal Navy would try to hunt down the rebels. The O'Briens and their fellow Patriots armed the *Unity* and the *Polly* and headed out to sea to await and attack the British warships sent out against them.

The wait ended on July 12, 1775. O'Brien and "his absurd fleet of two sloops" engaged the British warships *Diligence* and *Tapnaquishin* in what should have been an easy victory for the Royal Navy. By the fray's end, O'Brien had captured both of his foes.

O'Connell wrote:

Proudly he took his prize to Machias, to the amazement of the Continental authorities. O'Brien had shown the Provincial Congress the best and surest way to strike for liberty—crush English shipping; stop supplies reaching

The Battle of Machias, June 11–12, 1775. Jeremiah O'Brien and his men overcame and captured the armed schooner HMS *Margaretta*. *Courtesy of Library of Congress.*

134

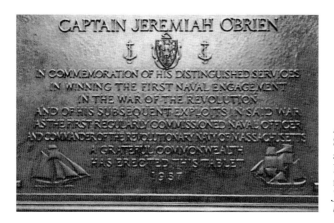

At the Massachusetts State House in Boston, a plaque honors the Revolutionary War naval feats of Captain Jeremiah O'Brien. *Photo by Peter F. Stevens.*

the army; build ships; call them privateers, if you will; commission them under letters of marque and reprisal. The Provincial Congress quickly did so. Soon he was commissioned our first naval commander; with the rank of captain in the Massachusetts marines. The war was on, and he was given the two vessels he had taken as warships.

As commander of the privateer *Hannibal*, which bristled with cannon and a crew of 130, Jeremiah O'Brien took the war to the British, ravaging merchantmen and warships alike. Then, in a seemingly stunning blow to the Americans, the British captured the bold seaman and tossed him into dank, fetid Millbank Prison, in England. To the surprise of no one who knew him, O'Brien broke out of the jail, was smuggled over to France and eventually made his way back home.

He was not the only O'Brien brother to bedevil the British at sea throughout the Revolution. John O'Brien commanded the aptly named privateer *Hibernia*.

At today's Massachusetts State House, people rush past the tablet honoring Jeremiah O'Brien. A pause to consider the contributions of the audacious mariner and descendant of Irish rebels is well worth a moment.

"EVERYTHING THAWS HERE EXCEPT OLD PAT"

Green Bloodlines in George Washington's Regiments

Whether one calls March 17 "St. Patrick's Day" or "Evacuation Day," the Irish can lay claim to both celebrations. Many men bearing Irish surnames were nestled behind bristling cannons that peered down from Dorchester Heights on that day in 1776. The redcoats, or "Lobsterbacks," were fleeing Boston aboard Royal Navy vessels straining to haul anchor and flee out of the harbor—which lay directly under the rebels' heavy guns.

Commanding the Patriots was George Washington, who held a deep regard for Irish-born troops serving in his ranks. He placed such a high estimate on their proven combat abilities that he honored that most cherished of Irish dates—St. Patrick's Day—in an era when the Irish, especially Irish Catholics, were hardly a favorite of many colonists.

On March 17, 1776, Washington was well aware that it was St. Patrick's Day and that many Irishmen had fought at Bunker Hill and had just helped drag cannon up the Dorchester slopes. He acknowledged both facts by ordering that the password of the day be "Saint Patrick."

Washington also proffered another proverbial tip of his tricornered hat to Patriots with Irish surnames as the British troops boarded their transports. On that momentous day, he had General John Sullivan countersign the dispatch making "Saint Patrick" the army's official watchword.

The son of an Irish schoolmaster who had emigrated from Kerry or Limerick to Berwick, Maine, in 1723, Sullivan was one of many rebels

who either hailed from Ireland itself or were the sons of native-born Irish. On St. Patrick's Day of 1776, as one of Washington's most trusted officers, Sullivan had long recognized the rebels' need for heavy artillery to enforce the siege of Boston. Washington had received, on December 17, 1775, a letter from Colonel Henry Knox, a man of Irish lineage. Knox had been sent on a mission to Fort Ticonderoga, in Upstate New York. The fortress, taken by rebel Ethan Allen and his Vermont Green Mountain Boys, contained the heavy artillery so sorely needed by Washington.

Knox wrote: "I hope in sixteen or seventeen days to present to your Excellency [Washington] a noble train of artillery, the inventory of which I have enclosed."

According to historian James Bernard Cullen:

> *Colonel Knox kept his word. With an enterprise and perseverance that elicited the warmest commendations, he brought, over frozen lakes and almost impassable snows, more than 50 cannons, mortars, and howitzers. With this train Washington was enabled to strengthen his position, and to make a more decisive move against the enemy. Colonel Knox was of a family that originally came from near Belfast. His career was a brilliant one. He commanded the artillery corps, and the effective work of his guns at Trenton, Princeton, Germantown, and Monmouth made him distinguished among the American generals. He was born in Boston, July 25, 1750.*

Among the native-born Irishmen in Washington's ranks near Boston on March 17, 1776, was Colonel Stephen Moylan, the dashing commander of Moylan's Dragoons. Born in Cork, Moylan was the brother of the Roman Catholic bishop of that city, and from the American camp in January 1776, he wrote to his brother: "Everything thaws here except old Pat. He is still as hard as ever crying out for powder—powder—ye gods; give us powder!"

Cullen notes: "Moylan Street at the [Boston] Highlands obscurely keeps his memory among us." Throughout the Revolution, Moylan proved one of the Continental army's most daring and resourceful officers, as well as a personal favorite of Washington.

While Irishmen eagerly joined the rebels' cause out of a desire both for independence and a chance to settle historical scores with the British, the Crown encountered pronounced difficulty in recruiting the Irish in Ireland and in the thirteen colonies to don the scarlet tunic of the British army and

Henry Knox, of Irish roots, and his men dragged cannons from Fort Ticonderoga to drive the British from Boston. *Courtesy of Library of Congress.*

march into battle beneath the Union Jack against Washington's troops. One of Washington's generals, Arthur Lee, another officer with Irish ancestors, wrote the following to Washington: "The resources of the country—that is to say, England—are almost annihilated in Germany, and their last resource is to the Roman Catholics of Ireland; and they have already experienced their unwillingness to go, every man of a regiment raised there last year having obliged them to ship him off tied and bound. And most certainly the Irish Catholics will desert more than any other troops whatever [once they were landed in America]."

An event proving George Washington's ongoing respect for both the Continental soldiers born in Ireland and those descended from Irish immigrants unfolded with his St. Patrick's Day proclamation of March 16, 1780. At his desk in his army's encampment at Morristown, New Jersey, Washington signed the following General Order:

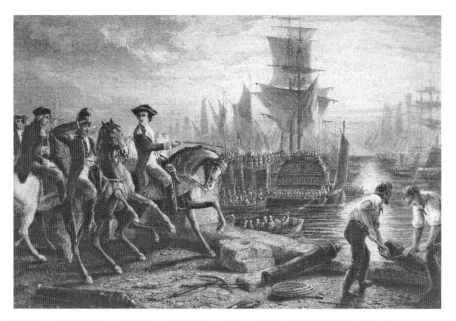

Soldiers of Irish lineage in George Washington's ranks forced the British to flee Boston on St. Patrick's Day 1776. *Courtesy of Library of Congress.*

The General congratulates the Army on the very interesting Proceedings of the Parliament of Ireland, and the Inhabitants of that Country, which have lately been communicated, not only as they appear calculated to remove those heavy and tyrannical oppressions on their trade, but to restore to a brave and generous People their ancient Rights and Freedom, and by their operation to promote the Cause of America. Desirous of impressing on the minds of the Army Transactions so important in their Nature, the General directs that all Fatigue and Working Parties cease for tomorrow, the 17ᵗʰ, a day held in particular Regard by the People of that Nation. At the same time he orders that as a mark of the Pleasure he feels on the occasion, he persuades himself that the Celebration of the Day will not be attended with the least Rioting or Disorder. The Officers to be at their Quarters in Camp, and the Troops of each State Line, are to be kept within their own encampment.

For the army's "sign" and "countersign" on St. Patrick's Day of 1780, Washington chose the passwords "Patrick" and "Shelah" (a scholar notes that the latter term referred to "one of the historic personifications of Ireland").

One look at the muster rolls of the Continental army proves the Irish presence on March 17 at Dorchester Heights and throughout the Revolutionary War. They witnessed what their countrymen on the "old sod" could only dream of: the British in full flight.

In Boston today, March 17 fittingly marks both St. Patrick's Day and Evacuation Day—the celebration alike of Ireland's venerated saint and the day the redcoats departed Boston for good.

"TRULY MAGNIFICENT!"

The Boston Irish Montgomery Guards

On the morning of September 12, 1837, the word passed swiftly through the ranks of the Boston Brigade. The Montgomery Guards, in their green uniforms and jaunty caps emblazoned with the harp of Erin, began to assemble at the brigade's rear, the unit's designated spot as the newest company. Suddenly, one of the brigade's nine other companies wheeled out of line and marched off the Boston Common, "with colors flying and their band playing Yankee Doodle." Five more would follow.

The crowd gathered to watch the brigade's fall muster erupted in cheers as the militiamen in the green uniforms could only gape. The six companies had just deserted their posts rather than parade through the city with the Irishmen of the Montgomery Guards. The insult notwithstanding, the men in the green coats would face worse from the Yankees of Boston that Sunday.

In an era when the nation was suspicious of a large standing army, Boston and other cities relied on volunteer militia companies that could serve as an "essential safeguard to the property, and public order in an age afflicted with riots." Many men in Boston of the 1830s deemed it their patriotic and civic duty to wear the uniforms of militiamen and revel in the Boston Brigade's parades in front of the cheering crowds, its marches into the countryside and its elegant suppers at the homes of well-heeled merchants and politicians. Until 1837, the membership of the Third Brigade, First Division, Massachusetts, had been exclusively Yankee in makeup, marching and drilling with their brethren in companies with names such as the

Lafayette Guards, the Boston Fusiliers, Mechanics' Riflemen, the Winslow Blues and the pride of the brigade, the City Guards. Their annual musters on the Common drew thousands of onlookers who applauded the infantry, cavalry and artillery units in their many-hued uniforms and accoutrements.

By 1837, many "Boston citizens of Irish blood" longed to prove their patriotism by forming their own militia company and had approached the city's government for permission to do so. Every attempt engendered brusque dismissal by Brahmin leaders. Then, in January 1837, a band of "naturalized Irishmen or sons of Irishmen" took a different tack. Before presenting the city council yet another petition requesting permission to form an Irish company, "many of the finest Catholics of Boston," including Andrew Carney and Thomas Mooney, approached several Yankee commanders of the Boston Brigade and persuaded them to support a "Catholic company."

Shrewdly, the Irishmen offered respected Yankee William S. Baxter as their prospective captain. This time, the city's politicians acceded to the petition, and the Boston Executive Council and Governor Edward Everett sanctioned the Tenth Company of Light Infantry, Irish American infantry.

Carney and his compatriots dubbed their unit the Montgomery Guards, in honor of the Revolutionary War hero General Richard Montgomery, the Irish-born Revolutionary War hero who was killed leading rebel troops in the assault on Quebec. Eager to prove they belonged in America, local Irishmen flocked to join the new company. But Carney and Mooney, delighted by the turnout, made an error—they unwittingly enlisted a number of local Irish who had lived in Boston several years but were not yet naturalized citizens. Legally, only American citizens could serve in the militia. The organizers of the Montgomery Guards held "a mistaken notion that a man acquired the privileges of American citizenship as soon as he had made his primary declaration looking toward naturalization." The mistake would come back to haunt the Irishmen.

The new militiamen donned green uniforms trimmed in gold and scarlet. On their cap plates were the gilded harp of Erin and an American eagle.

On June 11, 1837, the Montgomery Guards were called out to help the militia restore order between Irish and Yankee mobs during the Broad Street Riot. Their even-handed performance of duty won grudging plaudits from many Yankees.

The unit's first public parade unfolded on June 27, 1837, when the Irishmen, resplendent in their emerald coats and gleaming trappings, marched through Boston and, later, "together with their invited guests, sat

The Montgomery Guards, Boston Irish volunteers, were viewed with contempt and suspicion by the city's Yankee militia units. *Courtesy of Library of Congress.*

down to a sumptuous entertainment at Concert Hall" and then attended a reception "at the residence of Mr. Andrew Carney, in Ann Street."

The exhilarating day led Carney and his fellow Guards to think they had won a measure of Yankee Boston's respect and acceptance, previously unknown. The Boston Irishmen were wrong.

The very sight of the green uniforms and the caps bearing the Harp of Erin aroused fury from legions of locals who despised the Irish and the Catholic faith. They derided the Montgomery Guards "as simply a corps of armed foreigners on American soil who might be expected to make serious trouble."

The sight of the armed Irishmen equally enraged the Yankee militiamen, who worried that their "pure" American ranks were sullied by "low foreigners." In a series of "daily conversations," six companies of the city brigade plotted a public display of their contempt for the Irish. They chose the annual fall muster on Boston Common as the date of their demonstration.

At 7:30 a.m. on September 12, 1837, the ten companies of the Boston Brigade assembled along the grassy expanse of the Common for a day of public drill, maneuvers and a march across the city. One by one, the units formed into line at 9:00 a.m., with the oldest companies first in order. The Montgomery Guards, the newest band, were supposed to march as the brigade's rearguard.

As the nine Yankee companies took their places, "a whisper ran through the ranks." Then, while Captain Baxter wheeled the Montgomery Guards into line, the City Guards—"the ringleaders"—tramped from the procession and off the Common to the fife strains and drumbeats of "Yankee Doodle." The Lafayette Guards, the Boston Fusiliers, the Washington Light Infantry, half of the Mechanics' Riflemen and the Winslow Blues soon joined the first mutinous company. To show their antipathy toward the Irish, six companies abandoned the field "without their officers and in flagrant disobedience to orders." As the mutineers marched to their armories, a crowd cheered their every step.

As the remaining units on the Common conducted their drills in an abortive display, the situation degenerated from bad to worse. Yankee throngs jeered the Irish militiamen and began to pelt them with stones. Then "rowdies" tore down the marquee viewing stand of the Montgomery Guards.

The order to dismiss was given near 6:00 p.m. The dispirited and nervous Irishmen headed toward their armory, in Dock Square, near Faneuil Hall. All along their route, Yankee crowds gathered, and hundreds dogged the column's rear as "opprobrious epithets pealed ceaselessly."

Soon, paving stones, bricks, coal and bottles rained down on the green-coated volunteers. Constables did not budge, and none of the other militia companies attempted to help the Montgomery Guards.

Historian Edward Harrington writes: "For soldiers so outrageously provoked and in no slight peril of their lives, the temptation must have been great to use the arms which they held in their hands. Had they done so, the fray might easily have developed into the bloodiest riot that Boston had ever known, and it is likely that this was just what the leaders of the mob were aiming at."

With Captain Baxter barking out orders to hold steady, the Montgomery Guards, many of them with blood streaming down their faces, never broke ranks or fired at their tormentors; but as the Guards neared their armory, they encountered over three thousand people surrounding the building and ready to torch it.

Mayor Elliot and a small host of Brahmin leaders materialized in front of the armory and somehow persuaded the rioters to disperse.

In several newspapers, outrage at the actions of the six mutinous companies and at the mob was pronounced but short-lived. Although Governor Everett disbanded the offending units on February 23, 1838, new ones featuring most of the dismissed men were soon formed. On April 6, 1838, he disbanded the Montgomery Guards on grounds that their "continued existence…would constitute a chronic menace to peace and order."

The last official act of the Montgomery Guards was to issue "a vigorous and manly farewell address to the public: 'The innocent are made to suffer as the guilty,' the unit stated, 'and the Sovereign State yields its power to a fractious mob in the city of Boston.'"

Even though the Montgomery Guards' service had been short-lived, its Irish volunteers comported themselves with a collective dignity that was "truly magnificent."

PROVING THEIR METTLE

Colonel Cass and the Ninth Irish Regiment

I n American military annals, "the Fighting Sixty-Ninth" New York Regiment is steeped in legend. Comprised largely of Irish Americans, the unit deserves its hard-won status. The same can be said of the Ninth Massachusetts Regiment—"the Fighting Irish Ninth." The gallant organizer and first commander of the United States Army regiment was the North End's Colonel Thomas Cass.

Born in Farmly, Ireland, in 1821, Cass immigrated to Boston as a boy with his family. As with most Irish immigrants to the city in the pre-famine era of the 1820s and 1830s, the family lived in the North End slum buildings that clotted Ann and Water Streets, among others. Thomas attended public school for a few years. Those classrooms were not always welcoming to boys and girls with a Celtic lilt in their speech. He eventually was apprenticed as a currier—a tanner—and went into business with his father in the North End, marrying and raising a family.

In the following years, Cass became a successful businessman and was elected to the city's school committee. He enlisted with numerous other local Irishmen in the Columbian Artillery of Massachusetts's volunteer militia and rose to the rank of captain, convinced that local Irishmen were as patriotic and willing to fight for their new country as any Yankee. In 1861, Cass began to recruit Irishmen throughout April and May to raise a regiment. The effort's primary funder was Boston Irish entrepreneur Patrick Donahoe, the publisher of the *Pilot*. Six companies of Irishmen from Boston and one each from Salem, Marlborough, Milford and Stoughton signed the muster rolls of the Ninth Massachusetts Volunteer Infantry.

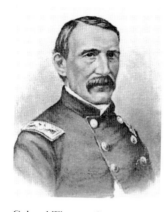

Colonel Thomas Cass, who rose from Boston's tenements to valiantly lead the Twenty-Eighth Massachusetts Irish Regiment during the Civil War. *Courtesy of Library of Congress.*

Cass was named colonel and commander of the regiment, which set up an encampment at Faneuil Hall before being assigned to the Union base on Long Island in Boston Harbor. There, the regiment was officially mustered into the Federal army on June 11, 1861.

As the Ninth began to drill, its commander looked every inch a man born to lead troops in battle. With an athletic frame, a bristling mustache and penetrating eyes, Cass took his men's measure beneath his brimmed blue Federal officer's cap. Cass liked what he saw in the Ninth.

The regiment was ordered to depart to Washington, D.C., on June 25, 1861, and join the Army of the Potomac. Throngs of people—Irish and Yankee, Catholic and Protestant alike—turned out to cheer the regiment as it marched in neat array, brass buttons glittering on blue tunics, muskets shouldered, through Boston's streets to an official ceremony in front of the State House, where Governor John J. Andrews not only lauded the troops but also uttered disturbing words for anti-Irish bigots, asserting that the nation must view alike "its native-born citizens and those born in other countries."

At the State House, Cass accepted the regimental colors—a green banner emblazoned with the gilded words "Gentle when stroked, fierce when provoked."

Equally upsetting to Yankees who loathed the Irish were the sentiments of true-blue Brahmin maven Mrs. Harrison Gray Otis, who presented the Ninth with a flag adorned with the following words: "As aliens and strangers thou didst befriend us. As sons and true patriots we do thee defend."

To thunderous cheers, with the bold green flag nodding in the June breeze, Cass led his men to the waterfront, where troop transports waited to convey the regiment south and off to war. In the ranks of General George McClellan's Army of the Potomac, the Ninth would carry the banner amid Virginia's pine forests, swamps and hills during the Union's savage and ill-fated Peninsula Campaign in 1862.

Men of the Twenty-Eighth Massachusetts Irish Regiment gathered for prayer during the savage 1862 Peninsula Campaign in Virginia. *Courtesy of Library of Congress.*

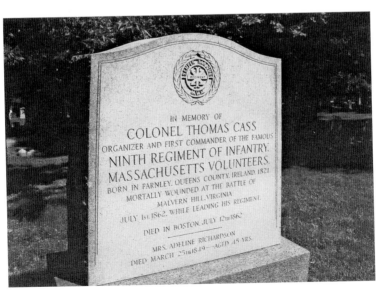

The gravestone of Colonel Thomas Cass, mortally wounded while leading his troops in battle in 1862. *Photo by Peter F. Stevens.*

A few days later, the Ninth was welcomed along the Potomac by President Abraham Lincoln and set up camp near Arlington, Virginia, drilling each day and helping to build a small bastion it dubbed "Fort Cass."

The regiment broke winter camp on March 10, 1862, and headed south to Fort Monroe, Virginia, on March 23 as part of the Army of the Potomac, commanded by General George B. McClellan. His goal was to drive to Richmond, the Confederate capital, and crush the rebellion. In the soldiers' parlance of the day, the Ninth was about to "see the elephant"—battle.

In June 1862, the Ninth Massachusetts earned the praise of its fellow regiments and that of its Confederate foe at the Battles of Mechanicsville and Gaines Mill. As Cass and his regiment tore apart the Rebels again and again, the Boston Irishmen's valor came at a high price. By the end of the Battle of Malvern Hill, on July 1, 1862, nearly 50 percent of the Ninth had been killed or wounded.

Their commander was among that number. Shot in the face and mouth, the grievously wounded Cass was transported home. He died in Boston on July 18, 1862, and was buried with full military honors at Mount Auburn Cemetery. His regiment fought valorously until 1864, when it was officially mustered out of service and the remnants returned to Boston to a stirring public welcome.

Today, a statue of Colonel Cass stands in the Boston Public Garden. The sculpture is a fitting testimonial to a man who proved that he and his fellow Irish would fight and die to protect the Union.

For further reading, see *Commanding Boston's Irish Ninth: The Civil War Letters of Colonel Patrick R. Guiney, Ninth Massachusetts Volunteer Infantry*, by Christian Samito.

30

DUBLIN IN FLAMES

The Boston Irish and the Easter Rising

O n April 26, 1916, shock and excitement gripped Boston's Irish
neighborhoods. Readers gasped at the *Boston Globe*'s headline:
"Serious Revolt Rises in Dublin—Armed Sinn Men Fight British
Troops." The rebels had proclaimed "the birth of the Irish Republic."

The fiery news of the Easter Rising, raging in Dublin since Monday,
April 24, had finally reached Boston, and for the next few weeks, the Boston
Irish pored over the front pages of the *Globe*, the *Herald* and other local
newspapers as they covered the valiant but ill-fated revolt led by Padraig
Pearse, James Connolly and others against the British. In Boston, people
frantically tried to telegraph relatives in Dublin and elsewhere throughout
the island. Few got through for nearly two weeks, as Dublin's windows
shattered from the roars and rumbles of British artillery and the nights
were lit up by the flashes of the fieldpieces' muzzles and the flaming sheets
of small-arms fire.

The rebellion had erupted on Easter, April 24, when a band of one
thousand to fifteen hundred Irishmen armed largely with German rifles
seized the sprawling General Post Office on Sackville Street (now O'Connell
Street) and other key points throughout the city, catching the British army
by surprise. Michael Collins, Eamon de Valera and the other rebels dug in as
best they could and braced for the British onslaught. By the time news of the
rising reached Boston's papers, the British had imposed martial law on the
city and were pounding the Irish positions. The gunboat *Helga* reduced rebel
meeting-place Liberty Hall to a charred ruin. British batteries and troops

Easter Rising poster, Dublin, 1916. At first, Boston Irish support for the uprising against Britain was mixed. *Courtesy of Library of Congress.*

took positions at Trinity College, and troops surrounded the rebels' positions and inched ever closer.

The front page of the Wednesday, April 24 edition of the *Boston Evening Globe* proclaimed in a bold black headline: "Dublin under Martial Law." Brahmins likely nodded their assent to a *Globe* story picked up from London deriding the rising as "an act of folly by political lunatics—old disgruntled cranks and young Sinn Feiners." Adding to the excitement in Boston were newspaper accounts contending that documents seized from a German spy proved that "prominent Irishmen in the United States" had been working with Germany to foment and finance the revolt in Dublin. Nervously, Boston's Irish awaited the inevitable news that the British had crushed the insurgents.

The grim news materialized in the morning editions of the *Herald* and the *Globe* on Thursday, April 27, 1916. Emblazoned on the front page of the *Globe* were the words "British Defeat Dublin Rebels." The headline was a bit premature, but in Dublin, the British troops were boring in for the collective kill, some soldiers shooting civilians on sight, because many of the rebels did not wear uniforms.

"On that day [Thursday]," one account relates, "attacks were made on Boland's Mill, the men in the South Dublin Union were forced to give ground and there was shelling of the General Post Office which began to burn from the top down. Connolly was wounded twice. The first wound he hid from his men, but the second was more serious, for one foot was shattered and he was in great pain. With the aid of morphia he carried on directing the battle as he could. The Dublin fires were now a great conflagration. With the streets full of small arms fire and the water supplies often cut, these could not be dealt with. Still, no major rebel strongpoint surrendered."

The *Evening Globe*'s Friday, April 29, 1916, issue revealed: "Parts of Dublin in Flames. Street Fighting Continues." Citing a report from London, the paper stated, "One dispatch received from Ireland, this afternoon, says that Sackville and Grafton Streets in Dublin are in flames and that artillery is being used on the houses, the inhabitants having been removed."

Later, eyewitnesses would assail the "truth" of the latter statement. "Street fighting continues," the report noted, "and there is much looting, but the reinforced military is making steady progress.

"Most of the shops are closed, and passenger communication is still cut off."

As any Boston Irish who had attempted to send a telegram to their old homes had learned, "normal telegraph, telephones and mail service with

Ireland have not been restored, and existing means of communication are subject to such a strict censorship that it is possible to obtain only fragmentary information."

The *Globe* and the *Herald* ran scraps of information describing desperate fighting in Dublin on Friday. When Connolly ordered a number of female rebels to leave the burning General Post Office, the end loomed for the battered Irish. Boston's Irish would soon learn that in a last savage battle along King Street, near the Four Courts, approximately five thousand British troops with armored cars and artillery required twenty-eight hours to advance about 150 yards against two hundred rebels. The sight of writhing and screaming comrades amid motionless ones torn apart by Irish fire on King Street ignited a fury among many of the British soldiers pressing closer to the rebels. An article notes: "It was then that the troops of the South Staffordshire regiment bayoneted and shot civilians hiding in cellars. And now it was all over. On Saturday morning [April 29] Pearse and O'Connell surrendered unconditionally."

In Boston, as elsewhere in the United States, many Irish viewed the rebels as heroes from the first news of the revolt. But many priests denounced Pearse, Connolly, Collins, De Valera and company as criminals against proper authority at war against "The Hun." Many Boston Irish did not yet know how to assess the doomed Easter Rising. Newspapers carried accounts of crowds in Dublin jeering and hurling invectives at the ragged, bloodied rebels as they were marched through the street to prison. Then, the reprisals by the British came, and everything changed in Dublin and across the Atlantic in Boston.

In London, the cabinet issued Major General Sir John Maxwell direct and secret orders that the leaders of the Easter Rising were to be stood in front of a drumhead court-martial quickly, sentenced to death and cut down by a firing squad. Only after the firing squad had dispatched the rebels was the public to learn of the executions. The British government believed that the brutal sentences would cow the remaining rebels and that the Irish public, so many of them angry at Pearse, Connolly and their men for the carnage they had brought upon Dublin, would accept or even applaud the executions. On every count, the British cabinet guessed wrong.

The *Herald* and the *Globe* delivered the harsh news on May 3, 1916. "Organizers of the Irish Republic Are Executed," the *Herald's* front page announced. "Four signers to the republican proclamation in Ireland have been tried and found guilty and were shot this morning [May 3]. Patrick H. Pearse, the provisional president of Ireland, James Connolly, commandant

Protests for Irish freedom erupted in Boston and all across the United States following the Easter Rising. *Courtesy of Library of Congress.*

general of the Irish Republican army, James J. Clarke and Thomas McDonagh were those executed."

The *Globe* informed readers that "Three Rebels Were Shot." The front-page story stated, "Justice had been swift in the case of the leaders, of the Sinn Finn rebellion. Three of the ringleaders, signatures of the short-lived Irish republic, paid the supreme sacrifice."

Within weeks, mass Irish and Irish American revulsion at the secret trials and firing squads rocked Parliament. In Boston and New York, the Irish denounced the British and, as in Ireland, conferred martyr status on the executed men. Enflaming passions to a white-hot degree was the manner in which the British had killed Connolly, who was dying from his battle wounds and tried while lying in bed in his hospital room. Since he could not stand, he was placed in a chair in the yard of Kilmainham Gaol, in Dublin and blasted from it by the firing squad.

Just a few years after the furor following the Easter Rising, Boston's Irish community accorded Eamon de Valera, who had been spared a firing squad for his role in the rebellion, a triumphant welcome at South Station and Fenway Park.

BOSTON'S "GANGS GREEN"

Irish Mobsters

Since the capture, trial and prison murder of James "Whitey" Bulger, one might be steered into believing that he created the Boston Irish "Mob." How accurate is that notion, and where does James Bulger fit in the "pantheon?" In his seminal book *Paddy Whacked: The Untold Story of the Irish American Mob*, author, journalist and organized-crime chronicler T.J English tracks the rise of Irish American crime syndicates from the mid-1800s to the present. English, in an interview with this author, reflected that Bulger came to head the Boston Irish crime scene the "usual way"—through street smarts, cunning and ruthlessness. However, what always set Bulger apart, English contends, was a combination of intelligence, coldness of temperament and an almost uncanny ability to "play people," from fellow gangsters to FBI agents and other law-enforcement officers.

Bulger stands as the most infamous Boston crime boss, but he was hardly the first. Loosely organized but brutal bands of thugs sprouted in Boston's Irish wards by the turn of the twentieth century. The Gustin Gang was the first to dominate the local turf. Its name was derived not from any of its leaders, but from a street off Old Colony Avenue in South Boston. Founded by Steve Wallace with his brothers Frank and Jimmy around 1915 and first nicknamed the "Tailboard Thieves," the gang's specialty was to hijack delivery trucks at intersections.

Frank Wallace soon proved to be the "brains" of the operation, and with Steve providing the "muscle," the gang unleashed a string of armed robberies in addition to its trademark hijackings for a decade or so.

Frankie Wallace, brutal Roaring Twenties leader of Boston Irish Gustin Gang. He was gunned down by rivals. *Courtesy of Boston Public Library.*

In 1920, with the passage of Prohibition, a new enterprise—bootlegging—opened up for the Gustin Gang. The Wallaces had already cultivated relationships with numerous politicians, high-ranking police officials and street cops alike, lawyers and informers through bribes and blackmail. Thanks to those contacts, the Irish gang's long trail of armed robbery, burglary, gambling and assault rarely resulted in much time spent in a cell. Countless charges against the Wallaces and their vicious minions were buried or dismissed.

Competing for customers with numerous other bootleggers, the Wallaces and their gang members proved brutal, but they knew there were limits when it came to a certain bootlegger named Joseph P. Kennedy, who was amassing such deep political clout and protection that he was playing on a far different level. The Gustin Gang carved out "rum-running" turf in and around its own South Boston shoreline, landing its own illicit shipments and personally delivering the bootleg liquor to local speakeasies as paid-off cops and Prohibition agents looked the other way. Before long, Gustin Gang members sporting fake Prohibition agents' badges were hijacking other bootleggers' shipments and selling them to their own customers.

Although other Irish gangs operated out of Somerville, Charlestown, Dorchester and Roxbury during Prohibition, the Gustin Gang ruled the proverbial roost. But they soon faced resistance and rage from Italian gangsters entrenched in Boston's North End and determined to end the Wallace brothers' contempt for any unspoken turf rules, especially after the Gustin Gang hijacked several trucks crammed with bootleg beer belonging to Joe Lombardi's North End gang, whose headquarters were at the C.K. Importing Company.

Lombardi and fellow gangster Phillip Bruccola convinced Frankie Wallace to attend a parley, or sit-down, in the North End. Whether out of cockiness, stupidity or a blend of both, Wallace agreed. He and his lieutenant, Bernard "Dodo" Walsh, strode into the C.K. Importing Company office and were gunned down. If the Italians thought they had dealt the final blow to the Gustin Gang, however, Lombardi and his crew were dead wrong.

The Irish, under the ham-fisted leadership of enforcer Steve Wallace, still held on to some of their criminal clout in Boston and environs. The North End gangsters had sent their bloody message that they were not going anywhere either. Over the next few decades, the Irish and the Italian gangs battled each other. Slowly, the better-organized North End gang garnered more power than did the Gustins.

By 1960, an Irish gang resurgence materialized in the form of Somerville's Winter Hill Gang and the Charlestown Mob. The Winter Hill Gang, headed by James "Buddy" McLean, and the Charlestown Mob, led by Bernie and Edward McLaughlin, had been on decent terms for some time, but the rivalry exploded into the so-called Irish Mob War of the early 1960s. According to many sources, the proverbial spark occurred when George McLaughlin reportedly hit on the girlfriend of Winter Hill "associate" Alex "Bobo" Petricone, who, as actor "Alex Rocco," went on to play ill-fated Las Vegas mobster Moe Green in *The Godfather*. Two Winter Hill Gang members beat up McLaughlin so badly that he ended up in the hospital.

Bernie McLaughlin stormed over to Somerville to demand an explanation from Buddy McLean and the names of the men who had attacked George. McLean refused, and McLaughlin vowed to make him pay.

In short order, McLean killed Bernie McLaughlin in the heart of Charlestown. The war ended with Bernie and Edward McLaughlin and their lieutenants Stevie and Connie Hughes murdered and with George McLaughlin escaping death only because he was imprisoned. McLean was killed, too, by the Hughes brothers before they met their bloody end. Howie

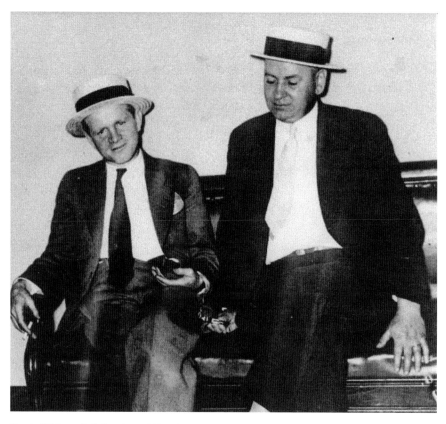

Stevie Wallace (*left*), brother of Frankie and co-leader of the Gustin Gang. After Frankie's murder, Stevie's local reign of terror continued. *Courtesy of Boston Public Library.*

Winter, McLean's top aide, not only succeeded him but also assimilated the shattered Charlestown Mob into the ranks of the Winter Hill Gang.

The Winter Hill Gang, known as the Irish Gang, proved far more formidable than the Wallace brothers and their men of the Prohibition era, vying for power with the Mafia in Boston and throughout the region. Perhaps the greatest illicit success of the Irish Gang was its fixing of horse races at tracks throughout the Northeast until 1979, when a federal investigation brought down Howie Winter and twenty-one others on an array of charges. The stage was set for a rising star on the criminal landscape to take over the remnants of the Irish Gang. Enter James "Whitey" Bulger.

Part IX

CHANGING THE LANDSCAPE

"THE FATHER OF THE SKYSCRAPER"

Louis H. Sullivan

A
t 22 Bennet Street in Boston, a bronze plaque marks the birthplace of "the Father of the American Skyscraper." Louis H. Sullivan, the son of a colorful Irish immigrant named Patrick Sullivan, would earn worldwide renown as an architect whose revolutionary designs turned steel, glass and concrete into the nation's first modern skyscrapers.

Louis Sullivan was born at the Bennet Street house (which still stands) on September 3, 1856. His father was described as "a pure-blooded Celt, who from a waif became a wandering musician, and by pride and ambition advanced himself to the proprietorship of an academy of dancing in London, traveled, studied dancing in Paris, and visited Geneva." In 1847, Patrick Sullivan immigrated to Boston and opened a music and dancing academy, where Brahmins paid top dollar to the talented Irish immigrant. Later, Louis Sullivan would joke that his father was not even sure whether "he was a Catholic or an Orangeman [member of an Ulster Protestant militant order]."

Patrick Sullivan married the beautiful Andrienne List, a cultured young woman of French and German parentage, in 1852. Because of his father's success, which stood in stark contrast to so many of Patrick's fellow Boston Irish of the era, Louis enjoyed a wide array of advantages not open to most immigrants' children. Still, young Sullivan "in looks, manner, and name was an Irishman."

According to Sullivan, he inherited his father's obsession with "grace, rhythm, and symmetry" and from an early age was "self-willed, emotional,

and outrageous and energetic." The son attended Boston's Brimmer School and Boston English High School, where one of the teachers had a profound impact on the youth's future. In his autobiography, Sullivan lauded English High instructor Moses Woolson, "who inculcated methods of thoughts, study, and work" that shaped Sullivan's future.

A drastic change in Sullivan's life unfolded in 1869, when his father took the ailing Andrienne to Chicago "in an effort to find a climate more lenient to the health of the mother." They left Louis behind in Massachusetts with his maternal grandparents. At about the same time, the thirteen-year-old Sullivan decided that he wanted to become an architect.

Sullivan experienced another jarring change, in 1871, when his grandmother died and his bereaved grandfather pulled up stakes to move to Philadelphia. Moving in with Boston friends of the family, Sullivan passed the entrance examination for the Massachusetts Institute of Technology and began his architectural studies in 1872 under the tutelage of William Robert Ware and his assistant, Eugene Letang. Letang was a "graduate of the famous, almost mythical École des Beaux-Arts in Paris, regarded by Americans, chiefly because of deeds of the distinguished sons Henry Hobson Richardson and Richard Morris Hunt, as the miraculous fountain-head of all architectural knowledge, and the open sesame to success and renown in the practice of architecture."

For the first time in his life, Sullivan grew frustrated by his studies: he found himself turning away from MIT's focus on classical Greek and Roman architecture and embracing such designs as the "recently completed Brattle Street Church tower in the virile and stimulating Romanesque as revived by Richardson."

On finishing a term (1872–73) at MIT, Sullivan left the school and traveled to New York to visit Richard M. Hunt, the "bluff old autocrat of American architects," for advice. Hunt was impressed by the young man, "slapped him on the back, and told him to go to Paris." Sullivan would, but first took a job with the Philadelphia architectural firm Furness and Hewitt. With the onset of the economic Panic of 1873, Sullivan found himself out of work and headed to Chicago, where his parents had moved and where the Great Chicago Fire had left much of the city in charred ruins. As the city rebuilt, Sullivan spied opportunities for a blossoming architect and landed a job with the firm of Major William Le Baron Jenney, whose landmark approach in using a steel "skeleton" for a tall building would greatly influence Sullivan.

The Boston-bred architect finally left for Paris in July 1874. According to Sullivan biographer Carl Condit, "only six weeks intervened between

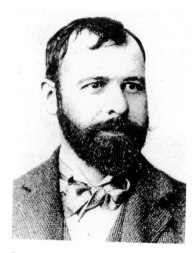

Louis H. Sullivan, the Boston-born and -raised architect acclaimed as the "Father of the Skyscraper." *Courtesy of Library of Congress.*

[Sullivan's] arrival and the examinations for entrance to the Beaux Arts....[He] laid out a schedule that demanded eighteen hours of study a day; at the end of a month, threatened with a collapse, he took a day off and recovered. He wore out three tutors, but passed his examination... and then took a trip to Rome" to study the Sistine Chapel. His time at the Sistine convinced him to adhere to a professor's credo that "here our demonstrations shall be so broad as to admit of no exceptions."

Sullivan climbed the proverbial architectural ladder, earning a reputation as a gifted and quick draftsman, and he took a post in 1878 as a "probationary partner" at the Chicago firm of Dankmar Adler. In May 1881, the firm became Adler & Sullivan, and Sullivan grappled with one of the major design dilemmas facing period architects: how to design large buildings with better light for offices and to erect them higher to maximize urban spaces.

Many historians point to Chicago's ten-story Home Life Insurance Building (1881), designed by Jenney, as America's first "skyscraper." It was Sullivan, however, who garnered acclaim for his design of Chicago's Auditorium Building, finished in 1890, by taking the skyscraper to its more modern incarnation. He applied the skeleton construction proven by Holobird and Roche in the Tacoma Building in Chicago to the revolutionary design of the ten-story Wainwright Building in St. Louis, Missouri, in 1881. He designed the building so that its steel-grid structure was visible, in a way that would shape future skyscrapers.

Sullivan designed several other skyscrapers over the decade, and in cities all across America, architects employed his techniques. His Transportation Building, featuring its "Golden Arch," proved the sensation of the 1893 World's Columbian Exposition in Chicago and was "the formal introduction of Sullivan's new conception of architecture to the world." His design of the Gage Building in Chicago was hailed as "an almost perfect solution— structurally and architecturally—of the steel-constructed skyscraper."

The world-famous architect married Margaret Hattabough in 1899, but a year or so later, his career began to decline. When Dankmar Adler died in

One of Louis Sullivan's early skyscrapers, in Chicago. *Courtesy of Library of Congress.*

1900 and Sullivan assumed control of the firm, his brilliance was offset by his difficult personality: "Sullivan's haughty and uncompromising attitude, nonconforming modes of life did little to inspire."

Although Sullivan continued to receive design commissions for the rest of his life, he sometimes struggled financially. His heyday had passed, but his former protégé Frank Lloyd Wright, who had been under Sullivan's tutelage at Adler & Sullivan in the late 1880s, never forgot Sullivan and long adhered to the older architect's famed maxim that "form follows function."

Wright helped Sullivan out financially. Still, by 1918, he was nearly broke. Wracked by kidney and heart disease, sixty-seven-year-old Louis Sullivan died in his sleep on April 14, 1924. Today, when one passes any of Boston's skyscrapers, Sullivan's legacy continues, and passersby can still glimpse the outside of the private house at 22 Bennet Street, where the man credited with establishing the skyscraper as the first "truly American form of architecture" was born.

33
A TREASURE IN THE ROUND

Father Cuddihy's Tower

No place in the United States except Milford, Massachusetts, has one. If one glimpses it along Route 85, one might find oneself hitting the brakes and gaping. For an instant, there is something of a flashback to vistas of rural Ireland. A round tower juts skyward—the only bonafide Irish round tower in the United States.

"How did a round tower get here?" one wonders. That startled reaction would have likely pleased the man behind the monument, Father Patrick Cuddihy.

In 1809, Patrick Cuddihy was born in Cashel, Ireland, in the nearby shadow of St. Patrick's Rock, where a round tower rises. Scholars believe that ancient Irish monks raised round towers to hole up from rampaging Vikings and other freebooters. Few who later knew Cuddihy doubted that the damp stone walls of St. Patrick's Rock made a deep impression on him from an early age, the stark tower stirring something both religious and nationalistic within him.

Cuddihy grew up in a land prostrate beneath British rule after the fury of the 1798 rising. As a youth, he was sent abroad to receive an education in preparation for the priesthood. In 1831, having studied at St. Isidora's and at the Sapienza, he was ordained in Rome by Cardinal Placido Zurla. The church assigned the Irishman, now in his early twenties and brimming with energy and purpose, back to his homeland.

A Franciscan, Cuddihy showed a few traits that somewhat bent the gentle tenets of the order's founder, St. Francis of Assisi. In postings at Limerick,

Clonmel and Waterford, Cuddihy not only proved a fiery spokesman for his faith but also an outspoken nationalist as he championed the cause of Ireland's downtrodden. "His vehement friendship for Daniel O'Connell" landed the rebellious priest in the vanguard of the "Liberator's" crusades for Catholic Emancipation and Repeal of the Union with Britain.

After the British government gutted the Catholic vote with landholding restrictions and the Repeal movement crashed in great part from O'Connell's controversial refusal to call Ireland's poorly armed Catholics to arms against crack Royal regiments, Parliament was "convinced that Ireland would be more easily ruled after he [Cuddihy] left it." Cuddihy did not leave right away. He remained in Ireland throughout the horrors of the famine, agonizing at the death, disease and mass exodus of his fellow Irish.

In 1852, Cuddihy, about fifty, finally joined the Irish diaspora and boarded a ship for Boston. When he met with Boston's Bishop John Bernard Fitzpatrick, the prelate did not find a priest sapped of his vigor by the death of O'Connell's dreams and the pall of the famine. Cuddihy was still a man of drive and passion, having arrived in America "with the prestige of a political martyr." Fitzpatrick and many others would learn that Cuddihy loved to "mix it up" with anyone who he thought was acting in a manner detrimental to the interests of his parishioners.

After stints at churches in the Berkshires, Cuddihy was sent in 1857 to Milford, Massachusetts, where many Irish had settled. He built St. Mary's Church, laying the cornerstone in 1866. On Christmas Day 1869, local Catholics heard Mass for the first time within the church's walls of pink granite, hewn from a Milford quarry. In 1896, granite from the same quarry built the walls of St. Mary's School and a graceful bell tower attached to the church.

Few parishioners could argue that Cuddihy had literally changed the local landscape. Fewer could have imagined his next construction project.

In the early spring of 1894, Cuddihy strode to the pulpit of St. Mary's and announced his intention to build a new tower—but not for the church. He intended to erect an Irish round tower in St. Mary's Cemetery.

"Why spend money and time on such a folly?" a friend chided.

Cuddihy retorted: "It may be folly, yet when you and I have passed away, the Irish in America will make a pilgrimage to the Irish Round Tower at Milford."

According to Paul Curran, an area historian and the prime force in a campaign to restore the round tower to the glory of a century ago, Cuddihy wanted other Irish immigrants and their descendants to remember the "old

sod." The round tower symbolized an age in which Irish monks, according to famed author Thomas Cahill, "saved Western civilization," doing so by hiding priceless manuscripts and books in the round towers that thwarted Ireland's many invaders.

On April 20, 1894, the *Milford Gazette* informed locals: "Fr. Cuddihy has commenced work on construction of a large tower in the new section of the Catholic cemetery. The tower, as we understand it, is to be modeled after one seen in Ireland by the venerable preacher on his travels."

Which round tower was the "one" fueling Cuddihy's project? Various sources would claim the priest's inspiration was the famous tower of Glendalough. Paul Curran, however, has proven this assertion wrong. Not only is the Glendalough tower taller, he points out, but also in 1896, Quaker Alfred Webb struck up a shipboard friendship with the gregarious priest on a voyage to Ireland and said that Cuddihy himself had revealed that the Milford tower was inspired by the one on Devenish Island.

From spring 1894 to fall 1895, barring one suspension of work when Cuddihy traveled to Ireland, the clangs of masons' chisels and the rasps of carpenters' saws pealed above the quarry and St. Mary's Cemetery. Cuddihy oversaw every detail of the project. He prowled the site with his "Bible" of round tower history and construction: *George Petrie's Ecclesiastical Architecture of Ireland*, an expensive tome that a friend had tracked down for the priest. While Cuddihy was undeniably involved in every detail of the work and was the guiding hand of the tower's design, Curran reports that the priest may have had technical help from a Rhode Island architect. Still, Cuddihy's "hand" lay on every inch of the monument's walls.

By May 24, 1894, the Milford tower's stones had risen fifty-five feet, tradesmen in St. Mary's flock translating Cuddihy's dream into pink granite reality. That same year, a Milford writer noted: "Next summer, when the tower will be completed, no more picturesque spot will be found....The round tower...the first ever built in this country, will stand there for ages like a sentinel watching over the city of the dead."

Although documentation of the tower's actual completion date is incomplete, Curran believes that it was finished no later than fall of 1895. Cuddihy's classic conical tower, 14 feet in diameter at the base, soared 73.6 feet to a coned roof and was crowned by a cross. At the top of the tower were four windows. Two other windows, narrower, were cut farther down the walls.

Cuddihy's designs did differ in one way from many Irish round towers: the Milford monument's door stands at ground level. In Ireland, tower doors

Father Cuddihy's
Irish round
tower soars amid
the gravestones
of St. Mary's
Cemetery, Milford,
Massachusetts. *Photo
by Peter F. Stevens.*

were built high above the base and could be reached only by retractable ladders as a defense against pillagers.

Father Cuddihy died in 1898, a man of "mental vigor and not a little physical strength" to the end. He was buried beneath St. Mary's bell tower, and his name is inscribed in five different spots inside the church.

Curran states, "Cuddihy believed that his round tower would become an Irish-American shrine for those who would want to have a glimpse of the old country right here in America." The very existence of that pink granite monument on American soil is Cuddihy's true legacy—perhaps America's only authentic Irish round tower.

34

THE HOUSE WITH
THE SHAMROCK SHUTTERS

Mayor Curley's Controversial Mansion

I t still stands in Jamaica Plain, more than a century since the grand
structure first began to take shape on St. Patrick's Day 1915. That
date is fitting, as the house's owner was no less than "Himself," James
Michael Curley.

Curley had decided to build a new home for his family. The house,
however, was not just any dwelling. Rising on a verdant two-acre tract that
offered a panoramic view of Frederick Law Olmsted's "green necklace"
along the Jamaicaway, Curley's mansion soon evoked collective questions
among his political enemies, the press and even some of his supporters.

Bostonians from the wards and Brahmin residences alike wondered how
and from where the city's controversial mayor was raising the sums for the
choice parcel of land and the manse gracing it.

Naturally, construction on "the house that James Michael Curley built"
commenced on St. Patrick's Day 1915. In virtually every way, the mayor's
new neighborhood stood as a polar political and cultural opposite to his
home turf, Ward 17 in lower Roxbury. Curley's property, pastoral in setting,
was flanked by stands of trees and by topiary gems similar to the shrubbery
that many of the wards' Irishmen had long pruned for Brahmins but that
few had ever owned themselves. In nearby Brookline, site of old Yankee
estates and the rarefied golf course and bridle paths of The Country Club,
lived the genteel set who viewed Curley as little more than a usurper.

From the moment that work crews begin setting the mansion's foundation,
questions swirled about Curley. He had commissioned the renowned

architect Joseph McGuinness to design a neo-Georgian estate similar to those Anglo-Irish structures that dotted Ireland, the mansion stretching and soaring over ten thousand square feet and featuring some twenty rooms. A tiled roof crowned the mayor's new home, which was adorned with a heated garage and surrounded by brick walkways. The landscaping was worthy of a country squire's estate.

As magnificent as the home's exterior was, visitors gaped at the trappings within the mansion's walls. A costly crystal chandelier illuminated the long dining room, where burnished mahogany-paneled walls reflected not only the chandelier's light and shadows but also an aura of the owner's power. The nearby first-floor hall sprawled sixty feet, and in virtually any direction that guests moved, either downstairs or upstairs, they encountered carved mahogany doors, twenty-eight in number.

With five children and his wife, Mae Herlihy Curley, in mind, the mayor had ordered McGuinness to incorporate state-of-the-art bathrooms in the home. The family reveled in the home's high ceilings, sat in front of fireplaces where flames cast their glow across imported Italian marble and reached for fixtures plated with gold. Perhaps the grandest touches of the wards' poor-boy-made-good were the front hall's bronze chandelier—five stories high and once having graced the Austro-Hungarian embassy in Washington, D.C.—and the spiral staircase that wound up three stories.

What, many of the "old crowd" wondered, had happened to the man who had come from, and spoken for, the people of the old neighborhood against the entrenched interests of Yankeedom? Curley, with typical aplomb, probably thought that he answered such questions with the carved shamrocks that graced the mansion's thirty white shutters. The emblems were hardly enough to quiet his Boston Irish foes already screeching the words "graft" and "corruption."

In the rough-and-tumble ranks of Boston Irish politics, Curley was ever battling enemies sporting similar Irish bloodlines but assailing him with a venom equal to that of his legion of Yankee detractors. Curley would recall how John F. Fitzgerald, who also had won the mayor's office, "joined my critics" over the Jamaicaway mansion. "A few years ago," chided Fitzgerald, "James M. Curley was working as a corporation inspector for $3 a day. The year before he was elected mayor, he paid nothing except a poll tax. Now he has a beautiful home on the Jamicaway, with furnishings from the home of Henry H. Rogers [a Standard Oil baron], who died worth [$1 billion]. He [Curley] recently disposed of a fine summer residence at Hull, bought since he became mayor."

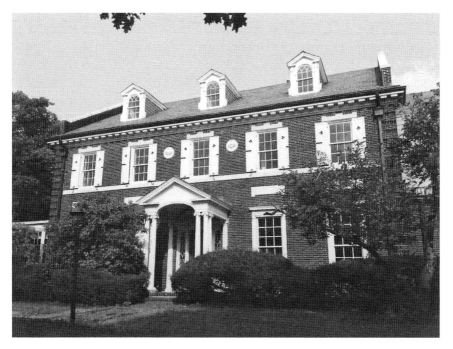

Mayor James Michael Curley's "Shamrock Mansion," on the Jamaicaway, Boston. *Photo by Peter F. Stevens.*

Curley, contending that Fitzgerald was the proverbial "pot calling the kettle black," retorted: "I might remark parenthetically that when John F. retired, he spent most of his on his estate in Hull, and he owned another fine home in Concord. It did not occur to him, apparently, that I disposed of one residence so I could purchase another."

That Curley was drawing from a questionable source or sources of funds was evident, writes Jack Beatty in his definitive Curley biography, *The Rascal King.* Beatty notes that in the 1950s, nearly four decades after the controversy over the Jamicaway mansion had erupted, John Henry Cutler, who ghostwrote the mayor's memoir, *I'd Do It Again,* asked Curley, "Governor, did you pay for the house?" Cutler recalled, "He gave me a wink so as if to say of course he didn't pay."

After more than a century of St. Patrick's Days, the Curley mansion still stands, "the house with the shamrock shutters."

Part X

CAPTAINS OF COMMERCE

"The Father of Boston Merchants"

John Cogan

or many years, historians asserted that Puritan Boston was composed wholly of English colonists, with perhaps a handful of Scots in the city's first century. Few scholars gave much consideration to the prospect that Irish settlers were in the mix.

That assumption began to come under academic fire at the turn of the twentieth century, as the Boston Irish amassed ever-increasing political clout in the city. Typical of claims that the Irish had established a foothold even among the first Puritan settlers of the Massachusetts Bay Colony is the murky saga of a man named John Cogan, who, according to Irish American historian James B. Cullen, "opened the first store in Boston."

In 1907, the *Journal of the American-Irish Historical Society* ran the following assessment of the Cogan story:

> For a quarter of a century he [Cogan] was prominently identified with the colony—from 1632 until his death in 1658. He probably came from Cork. The late John B. Reagan, of Dorchester, noted for his historical research regarding the Irish in America, said of the first of Boston's Keltic [sic] citizens: "Among those who came over in the so-called Winthrop fleet, composed of people from all parts, were several merchants from the maritime ports of Ireland, of whom John Cogan was one."
>
> In my researches for details of Cogan's career I found this reference to him from Lechford's Notebook: "Whether John Cogan, of Boston, Mass., was related to this family (the Cogans of Chard, Eng.) or not I [Lechford] do

The first Boston Town House stood near the site where, in 1634, John Cogan opened Boston's first store. *Courtesy of Boston Public Library.*

not know. He appears to have been from Devonshire, as in 1639 he gave Isaac Northcutt, of Honiton, a power of attorney to receive any legacy under the will of his mother, Eleanor Cogan, of Tiverton, in Devon."

Still, this would not prove that Cogan was English, as thousands of Irish have settled in England from an early period....

He proved himself a shrewd and energetic businessman and became wealthy.

In the 1930s, the "Cogan Claim" was addressed to the editor of the (Boston) *Herald*:

[Cogan] first went to Dorchester [Massachusetts], and had land allotted him there in 1630. The keen and far-seeing eye of the man of business quickly discovered that Boston was destined to be the location for men of his stamp, and he moved there in 1632. He, in company with Winthrop, Bellingham, Coddington, and others, laid the foundation of what is to-day the city of Boston. He was appointed by Governor Winthrop in 1633 a

commissioner to select the lands that were best adapted for agricultural purposes, that the colonists might not waste their energies in planting on land not adapted for their crop. He was one of the board of selectmen the first year of its existence, was one of the first to join the church, and so much was he esteemed by Rev. Mr. Wilson, the pastor of the first church in Boston, that Cogan was often consulted by him on worldly affairs. The lot on the north-east corner of State and Washington streets he purchased of Rev. Mr. Wilson, and erected a building on it; and on this spot, March 4, 1634, John Cogan from Ireland opened the first store in the town of Boston. To him belongs the Honor of being the father of Boston merchants. He was one of the charter members of the Ancient and Honorable Artillery Company. The name of Mr. Cogan is inseparably connected with the interests and progress of the first twenty-five years of Boston's existence. He was the owner of a great deal of real estate in the city and surrounding towns. Among his property was the lot corner of Beacon and Tremont Streets, known in our day as the Pavilion and Albion Hotel lot. It was 322 feet on Beacon street and 70 feet on Tremont street.

So, what is one to make of "John Cogan of Ireland?" In 2012, a gentleman named Bill Longman noted that his family's genealogical tree includes Boston's John Cogan. Longman writes that Cogan "was christened 5 Jan 1590 in Hertfordshire, England, and had several wives. To Dorchester and then was the first shopkeeper in Boston as of 1635. Died 27 April 1658."

Even the christening record does not preclude any Irish blood in Cogan's lineage. As noted, "Still, this would not prove that Cogan was English, as thousands of Irish have settled in England from an early period."

The historical record reveals that a small influx of the Irish were in fact in colonial Boston. Some converted from Catholicism to the majority Protestant faith of the local Puritans to gain acceptance in the community. Boston's first shopkeeper might well have been "John Cogan of Ireland." The strongest proof lays in his very surname.

"ONE OF GOD'S BEST NOBLE MEN"

Andrew Carney

I f society truly measures people by both financial success and charitable works, Andrew Carney ranks as one of the greatest rags-to-riches stories in America's annals.

Before there were "Horatio Alger" stories, there was Andrew Carney. Today, we have numerous politicians and corporate kings and queens who believe that charity does not begin at home or in the boardroom. Everyone is exactly where they deserve to be in life, some will say. No exceptions.

Andrew Carney believed otherwise and put those moral beliefs into action. In today's toxic moral climate, it is apt to look at the lessons that Carney, born in May 1794, can still impart.

Nineteenth-century historian James B. Cullen, in his book *The Story of the Irish in Boston*, writes: "Of the many representative Irishmen whom Boston can claim as an honored citizen, and refer to the history of his life with the utmost pride, none, perhaps, could have a more exalted position than Andrew Carney....To the poor of this city in times of sickness and poverty, he was a kind-hearted, whole-souled, generous friend and protector."

He was also a tough, pragmatic, innovative businessman who did not sacrifice ethics for fortune. Carney was born into abject poverty in Ballanagh, County Cavan, Ireland, on May 12, 1794. With only a limited education, he was apprenticed to a local tailor and learned the trade. After deciding that few opportunities to rise in Ireland existed for a poor Catholic, the twenty-year-old Carney immigrated to Boston in 1816 with

nothing except a trade and ambition far beyond what anyone who knew him back in Ireland thought attainable.

In Boston, he started out in the hardscrabble Irish neighborhood of Anne and Water Streets in the North End and found work "at the bench" of Kelley & Hudson, tailors, on State Street. "He began life," said Father John McElroy, a Jesuit founder of Boston College and a close friend, "with nothing but health and labor to rely upon."

Carney also had something else to rely on: his determination to be his own boss. After long years of work for Kelley & Hudson, he had saved enough to open a tailoring shop on North Street in partnership with Jacob Sleeper. The venture—equally split between an Irish Catholic immigrant and an established Yankee businessman—was an almost unheard of union in Brahmin Boston. The two entrepreneurs not only built up a large clientele with their deft and quick tailoring skills, but Carney & Sleeper, Clothiers, was also first in its profession to unveil "ready-made suits" that were priced for all incomes. A colleague remarked that Carney "was a very keen businessman, was exceedingly shrewd, and could see money in a transaction when others would be blind to the possibilities of the occasion."

After nearly two decades, Carney cashed out of the business in 1845; having amassed a fortune in his early fifties, he devoted his energies to help found the Bank of the Republic and the Safety Fund Bank (now Bank of America). A director of the John Hancock Life Insurance Company, he proved instrumental in both the foundation and the funding of Boston College, which, in his day, was located on Harrison Avenue, in Boston's South End, next to the Church of the Immaculate Conception.

As his fortune expanded, Carney, who had always made considerable contributions to both the Catholic Church's and the city's charitable institutions, turned even more of his energies and his fortune to aiding the sick and the downtrodden. He gave on a scale both personal and grand. Cullen writes: "Many a poor apple-woman of his time, presiding over her 'little stand,' was approached by the Irish merchant and tendered a half-dollar, with no change, in payment of his purchase of a pennyapple. He would walk away with the exclamation, 'Hush, my dear woman, don't say a word about!'"

Carney often found that when he boarded a streetcar for home at the end of the day, he had given away all the money in his wallet. In his expensive overcoat and suit, he would wait patiently for a familiar face, because even though he was one of Boston's wealthiest men, he did not have enough to pay the fare on the following day.

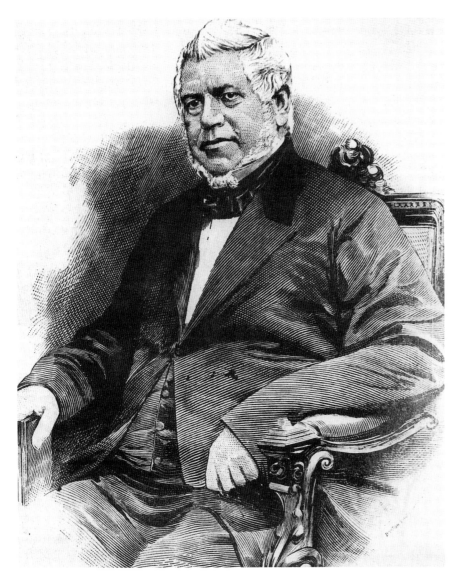

Andrew Carney, the Boston Irish Horatio Alger. Carney, born in Ireland, became one of the city's wealthiest and most philanthropic residents. *Courtesy of the* Boston Pilot.

In 1863, as the Civil War raged, Carney made a profound and long-lasting charitable impact on Boston's landscape—literally so. For the staggering price of $13,500, he purchased the Howe Mansion, atop Dorchester Heights. The house was still stunning but had fallen into some disrepair. Carney intended to renovate the site, which provided spectacular vistas of Boston

and the Harbor Islands. But he did not do so for himself. With its cooling summer breezes and its proximity to the city, the Irishman commissioned the renovation of the Howe Mansion into a hospital "to afford relief to the sick and poor." Cullen lauded how the Carney Hospital, run by the Sisters of Charity, was tasked to receive patients of all religious denominations. "Chronic, acute, and other cases are received."

Carney demanded that the institution bearing his name be "a hospital where the sick without distinction of creed, color or nation shall be received and cared for." In an era when ethnic prejudice, racism, elitism and greed ruled the roost, Carney's views were both astonishing and visionary.

Andrew Carney passed away the following year, 1864. His personal donations to the hospital totaled more than $75,000. Cullen and those who knew Carney speculated that his "humble beginnings in Ballanagh... [served] as the impetus for his sincere interest in the less fortunate." It is undeniable that Carney understood that hard work, ambition and talent are not always enough to guarantee success; as the adage goes, "life is unfair" for many. Despite his success, he never lost sight of those truths. Over the last three years of his life, he gave a stunning amount of money to charity.

Cullen writes that a business associate of Carney dubbed him "one of God's best noble men."

BIBLIOGRAPHY

Author's note: Essential sources for the book include the many newspapers and periodicals in and around Boston from the 1700s to the present, including the *Boston Pilot, Boston Courier, Boston Post, Boston Herald, Boston Globe* and many other newspapers. Within the chapters, these sources are cited.

Adams, William. *Ireland and Irish Emigration to the New World from 1815 to the Famine.* New Haven, CT: Yale University Press, 1932.

Ainley, Lesley. *Boston Mahatma: Martin Lomasney.* Boston: B. Humphries Inc. 1949.

Ames, Seth, ed. *The Works of Fisher Ames.* 2 vols. Boston: Little, Brown and Company, 1854.

Bailey, Ronald, et al. *Lower Roxbury: A Community of Treasures in the City of Boston.* Boston: Northeastern University Press, 1993.

Barrett, J.R. "Why Paddy Drank: The Social Importance of Whiskey in Pre-Famine Ireland." *Journal of Popular Culture* 11 (1977): 155–66.

Baum, Dale. *The Civil War Party System: The Case of Massachusetts, 1848–1876.* Chapel Hill: University of North Carolina Press, 1984.

———. "The 'Irish Vote' and Party Politics in Massachusetts, 1848–1876." *Civil War History* 26 (1980): 117–41.

Beals, Carleton. *Brass Knuckle Crusade: The Great Know-Nothing Conspiracy, 1820–1860.* New York: Hastings House, 1960.

Bean, William G. "Puritan Versus Celt, 1850–1860." *New England Quarterly* 7 (1934): 81–92.

Beatty, Jack. *The Rascal King: The Life and Times of James Michael Curley, 1874–1958*. Boston: Da Capo, 1992.

Billington, Ray Allen. *The Protestant Crusade, 1800–1860*. New York: Macmillan, 1938.

Blodgett, Geoffrey. "Yankee Leadership in a Divided City." In *In Boston, 1700–1980: The Evolution of Urban Politics*, edited by Ronald Formisano and Constance Burns. Westport, CT: Praeger, 1984.

Bridenbaugh, Carl. *Cities in Revolt: Urban Life in America, 1743–1776*. New York: Knopf, 1955.

———. *Cities in the Wilderness: Urban Life in America, 1625–1742*. New York: Oxford University Press, 1938.

Brown, Richard D. *Massachusetts: A Bicentennial History*. New York: W.W. Norton, 1978.

Brown, Thomas N. *Irish-American Nationalism, 1870–1890*. Philadelphia: J.B. Lippincott, 1966.

Burton, William L. "Irish Regiments in the Union Army: The Massachusetts Experience." *Historical Journal of Massachusetts* (June 1983): 104–5.

Cook, Adrian. *The Armies of the Streets: The New York City Draft Riots of 1863*. Lexington: University of Kentucky Press, 1974.

Cullen, James B. *The Story of the Irish in Boston*. Boston: James B. Cullen & Co., 1889.

Curley, James Michael. *I'd Do It Again: A Record of All My Uproarious Years*. Englewood, NJ: Prentice Hall, 1957.

Curran, Michael P. *The Life of Patrick Collins*. Washington, D.C.: Library of Congress, 1906.

Dezell, Maureen. *Irish America: Coming into Clover*. New York: Penguin Random House, 2001.

Diner, Hasia. *Erin's Daughters in America: Irish Immigrant Women in the Nineteenth Century*. Baltimore, MD: Johns Hopkins Univeristy Press, 1983.

Dinneen, Joseph F. *The Purple Shamrock: The Hon. James Michael Curley of Boston*. New York: W.W. Norton, 1949.

Erie, Steven P. *Rainbow's End: Irish Americans and the Dilemma of Urban Machine Politics, 1840–1985*. Berkeley: University of California Press, 1988.

Gallagher, Thomas. *Paddy's Lament: Ireland, 1846–1847*. New York: Mariner Books, 1982.

Galvin, John T. "Boston's Eminent Patrick from Ireland." *Boston Globe*, March 17, 1988.

———. "Boston's First Irish Cop." *Boston Magazine*, March 1975.

———. "The Dark Ages of Boston Politics." *Proceedings of the Massachusetts Historical Society* 89 (1977): 88–111.

———. "The Mahatma Called the Shots and Everyone Knew It." *Boston Globe,* June 4, 1990.

———. "The Mahatma Who Invented Ward 8." *Boston Magazine,* November 1975.

———. "The 1925 Campaign for Mayor Was a Four-Ring Circus." *Boston Sunday Globe,* August 21, 1983.

———. "Patrick Maguire: Boston's Last Democratic Boss." *New England Quarterly* 55 (1982): 392–416.

———. "There's Some Irish Green in the Brahmins' Blue Blood." *Boston ... March* 17, 1989.

———. "... It to City Hall." *Boston Globe,* December 7, 1984.

Goodwin, Doris Kearns. *The Fitzgeralds and the Kennedys: An American Saga.* New York: Simon & Schuster, 1987.

Green, James, and Hugh Donahue. *Boston's Workers: A Labor History.* Boston: Boston Public Library, 1987.

Griffin, William D. *The Book of Irish Americans.* New York: Three Rivers Press, 1990.

Hale, Edward Everett. *Letters on Irish Emigration.* Boston: *Boston Daily Advertiser* (serialized), 1852.

Haltigan, James. *The Irish in the American Revolution and Their Early Influence in the Colonies.* Boston: P.J. Haltigan, 1907.

Handlin, Oscar. *Boston's Immigrants.* Cambridge, MA: Harvard University Press, 1941.

Hanna, William F. "The Boston Draft Riot." *Civil War History* 36 (September 1990): 262–73.

Hart, Albert B. *Commonwealth History of Massachusetts.* 5 vols. New York: The States History Company, 1927–1930.

Hennesey, James. *American Catholics: A History of the Roman Catholic Community in the United States.* New York: Oxford University Press, 1981.

Higham, John. "The Mind of a Nativist: Henry F. Bowers and the A.P.A." *American Quarterly* 4 (1952): 16–24.

Hodgkinson, Harold D. "Miracle in Boston." *Proceedings of the Massachusetts Historical Society* 84 (1972): 71–81.

Hofstadter, Richard. *The Paranoid Style in American Politics.* New York: Vintage, 2008.

Holmes, Oliver Wendell. *Elsie Venner.* Boston Public Library (rare original copy), 1847.

Houston, Amanda V. "Beneath the El." *Boston College Magazine* (Summer 1988): 20–25.

Huggins, Nathan. *Protestants Against Poverty: Boston's Charities, 1870–1900*. Westport, CT: Greenwood Press, 1971.

Imminent Dangers to the Free Institutions of the United States Through Foreign Immigration. New York Public Library (rare original copy), 1854.

Jaher, Frederic Cople. "The Boston Brahmin in the Age of Industrial Capitalism." In *The Age of Industrial Capitalism in America*, edited by F.C. Jaher. Boston Public Library Special Collections, 1968.

Johnson, Paul. *The Birth of the Modern World Society, 1815–1830*. New York: Harper Collins, 1991.

Kane, Paula M. *Separatism and Subculture: Boston Catholicism, 1900–1920*. Chapel Hill: University of North Carolina Presss, 1994.

Katz, Michael B. *The Irony of Early School Reform: Educational Innovation in Mid-Nineteenth Century Massachusetts*. Boston: Teachers College Press, 2001.

Kennedy, Lawrence W. *Planning the City Upon a Hill: Boston Since 1630*. Amherst: University of Massachusetts Press, 1994.

Kleppner, Paul. "From Party to Factions: The Dissolution of Boston's Majority Party, 1876– 1908." In *Boston, 1700– 1980: The Evolution of Urban Politics*, edited by Ronald Formisano and Constance Burns. Westport, CT: Praeger, 1984.

Knobel, Dale T. *Paddy and the Republic: Ethnicity and Nationality in Antebellum America*. Middletown, CT: Wesleyan University Press, 1988.

Kurtz, Stephen G. *The Presidency of John Adams: The Collapse of Federalism, 1795–1800*. Philadelphia: University of Pennsylvania Press, 1957.

Lader, Lawrence. *The Bold Brahmins: New England's War against Slavery, 1830–1863*. New York: Dutton, 1961.

Lane, Roger. *Policing the City: Boston, 1822–1885*. New York: Atheneum, 1971.

Lapomarda, Vincent A. "Maurice Joseph Tobin, 1902–1953: A Political Profile and an Edition of Selected Public Papers." PhD diss., Boston University, 1968.

Leach, Jack. *Conscription in the United States*. Rutland, VT: C.E. Tuttle Co., 1952.

Leckie, Robert. *American and Catholic*. New York: Doubleday, 1970.

Lee, Basil. *Discontent in New York City, 1861–1865*. New York Public Library (microfilm), 1941.

Levin, Murray. *The Alienated Voter: Politics in Boston*. New York: Holt, Rinehart & Winston, 1960.

Levine, Edward M. *The Irish and Irish Politicians: A Study of Cultural and Social Alienation*. South Bend, IN: University of Notre Dame Press, 1966.

Lodge, Henry Cabot. *The Story of the Revolution*. New York: C. Scribner's Sons, 1898.

Lord, Robert H., John E. Sexton and Edward Harrington. *History of the Archdiocese of Boston*. 3 vols. New York: Sheed and Ward, 1944.

Lupo, Alan. *Liberty's Chosen Home: The Politics of Violence in Boston*. Boston: Little, Brown, 1977.

Luthin, Reinhard H. *The First Lincoln Campaign*. Cambridge, MA: Harvard University Press (reprint of 1944 edition), 2014.

Lyell, Sir Charles. *A Second Visit to the United States of North America*. 2 vols. New York: Harper & Brothers, 1849.

William D. "Butlerism in Massachusetts." *New England Quarterly* 33

Social Reform in Boston, 1880–

Society for the Protection of Human Rights, 1975.

McMaster, John Bach. *A History of the People in the United States from the Revolution to the Civil War*. 8 vols. New York: Appleton and Company, 1900.

Mehegan, David. "The New Bostonians." *Boston Globe Magazine* (January 3, 1982): 12–15.

Meister, Richard J., ed. *Race and Ethnicity in Modern America*. Lexington, MA: D.C. Heath and Company, 1974

Melville, Annabelle M. *Jean Lefebvre de Cheverus, 1768–1836*. Milwaukee: Bruce Publishing, 1958.

Meyers, Gustavus. *History of Bigotry in the United States*. New York: Random House, 1943.

Meyers, Marvin. *The Jacksonian Persuasion: Politics and Relief*. Palo Alto, CA: Stanford University Press, 1957.

Miller, John C. *The Federalist Era, 1789–1801*. New York: Harper & Row, 1960.

Miller, Kerby. *Emigrants and Exiles: Ireland the Irish Exodus to North America*. New York: Oxford University Press, 1985.

Mollenkopf, John H. *The Contested City*. Princeton, NJ: Princeton University Press, 1983.

Montgomery, David. *Beyond Equality: Labor and the Radical Republicans*. New York: Knopf, 1967.

Morrison, Samuel Eliot, ed. *Builders of the Bay Colony*. Boston: Northeastern University Press, 1981.

———. *A History of the Constitution of Massachusetts*. Boston: Right & Potter Printing, 1917.

———. *The Life and Letters of Harrison Gray Otis, Federalists 1765–1848*. 2 vols. Boston: Houghton Mifflin, 1913.

———. *The Maritime History of Massachusetts, 1783–1860*. Boston: Houghton Mifflin, 1921.

Morse, Samuel F.B. *Foreign Conspiracy against the Liberties of the United States*. New York: Van Nostrand & Dwight, 1836.

Mulkern, John R. *The Know-Nothing Party in Massachusetts: The Rise and Fall of a People's Party*. Boston: Northeastern University Press, 1990.

———— "Scandal Behind the Convent Walls: The Know-Nothing Nunnery Committee of 1855." *Historical Journal of Massachusetts* 2 (1983): 22–31.

Murdock, Eugene. *One Million Men: The Civil War Draft in the North*. Westport, CT: Greenwood Books, 1980.

———— *Patriotism Unlimited: The Civil War Draft and the Bounty System*. Kent, OH: Kent State University Press, 1967.

Nolan, Martin F. "Exit the Irish: A Hushed Last Hurrah." *Boston Globe*, November 3, 1993.

O'Brien, Michael J. *The Irish at Bunker Hill*. New York: Devin-Adair, 1968.

O'Connor, Thomas H. *Bibles, Brahmins, and Bosses: A Short History of Boston*. 3rd ed. Boston Public Library Edition, 1991.

————. *Boston Catholics: A History of the Church and Its People*. Boston: Northeastern University Press, 1998.

————. *The Boston Irish: A Political History*. Boston: Northeastern University Press, 1995.

————. *Building a New Boston: Politics and Urban Renewal, 1950–1970*. Boston: Northeastern University Press, 1993.

————. *Civil War Boston: Home Front and Battlefield*. Boston: Northeastern University Press, 1997.

————. *Fitzpatrick's Boston, 1846–1866: John Bernard Fitzpatrick, Third Bishop of Boston*. Boston: Northeastern University Press, 1984.

————. "The Irish in New England." *New England Historical and Genealogical Register* 139 (July 1985): 187–95.

————. "Irish Votes and Yankee Cotton: The Constitution of 1853." *Proceedings of the Massachusetts Historical Society* 95 (1983): 88–99.

————. *Lords of the Loom: The Cotton Whigs and the Coming of the Civil War*. New York: Charles Scribner's Sons, 1968.

————. *South Boston: My Home Town*. Boston: University Press of New England, 1994.

O'Connor, Thomas H., and Alan Rogers. *This Momentous Affair: Massachusetts and the Ratification of the Constitution of the United States*. Boston Public Library, 1987.

O'Donnell, Edward T. *1001 Things Everyone Should Know About Irish American History*. New York: Broadway Books, 2016.

O'Hare, M. Jeanne d'Arc. "The Public Career of Patrick Collins." PhD diss., Boston College, 1959.

O'Toole, James M. *Militant and Triumphant: William Henry O'Connell and the Catholic Church in Boston, 1859–1944*. South Bend, IN: University of Notre Dame Press, 1992.

———. "'The Newer Catholic Ra[...] Catholicism in Boston, 1900–1940." *New England Quarterly* [...]

———. "Prelates and Politicos." In [...] *Community, 1870–1970*, edited b[...] O'Toole. Boston, 1985.

Palfrey, John Gorham. *A History of [...]* 1858–90.

Parkman, Francis. *Our Common [...]* Union, 1890.

Pessen, Edward. *Jacksonian Americ[...]*

Potter, George. *To the Golden Doo[...]* Boston: Little, Brown, 1960.

Quinlin, Michael. *Irish Boston: A Lively Look at Boston's Colorful Past*. Guilford, CT: Globe Pequot Press, 2004.

Rice, Madeleine Hooke. *American Catholic Opinion in the Slavery Controversy*. Gloucester, MA: Peter Smith, 1964.

Robinson, William S. *"Warrington" Pen Portraits*. Boston: Edited and published by Mrs. W.S. Robinson, 1877.

Russell, Francis. *City in Terror: 1919, the Boston Police Strike*. New York: Viking, 1975.

———. *The Knave of Boston and Other Ambiguous Massachusetts Characters*. Boston: Quinlan Press, 1987.

Ryan, Dennis P. *Beyond the Ballot Box: A Social History of the Boston Irish, 1845–1917*. Amherst: University of Massachusetts Press, 1989.

Samito, Christian. *Commanding Boston's Irish Ninth: The Civil War Letters of Colonel Patrick R. Guiney*. New York: Fordham University Press, 1997.

Sanders, James W. "Catholics and the School Question in Boston: The Cardinal O'Connell Years." In *Catholic Boston: Studies in Religion and Community, 1870–1970*, edited by Robert E. Sullivan and James M. O'Toole. Boston, 1989.

Schabert, Tilo. *Boston Politics: The Creativity of Power*. Berlin and New York: Walter de Gruyter & Company, 1989.

Schlesinger, Arthur B., Jr. *The Age of Jackson*. Boston: Little, Brown, 1953.

Schultz, Stanley K. *The Culture Factory: Boston Public Schools, 1789–1860*. New York: Oxford University Press, 1973.

Schwartz, Harold. "Fugitive Slave Days in Boston." *New England Quarterly* 27 (1954): 191–212.

"Shamrocks and Shillelaghs: The Phenomenon of Ethnic Mayors in Boston Politics." Forum 350, John F. Kennedy Library, Boston, September 16, 1980.

Shannon, William V. *The American Irish*. New York: Macmillan, 1963.

Shapiro, Samuel. "The Conservative Dilemma: The Massachusetts Constitutional Convention of 1853." *New England Quarterly* 3 (1960): 207–24.

Solomon, Barbara M. *Ancestors and Immigrants: A Changing New England Tradition.* Cambridge, MA: Harvard University Press, 1956.

Stack, John F., Jr. *International Conflict in an American City: Boston's Irish, Italian, and Jews, 1934–1944.* Westport, CT: Greenwood Press, 1979.

Stevenson, Louise. "Women Anti-Suffragists in the 1915 Massachusetts Campaign." *New England Quarterly* 52 (1979): 80–93.

Strahinich, John. "Only Irish Need Apply." *Boston Magazine* (March 1993).

Sullivan, Robert E., and James M. O'Toole, eds. *Catholic Boston: Studies in Religion and Community, 1870–1970.* Boston: Roman Catholic Archbishop of Boston, 1985.

Tager, Jack. "The Massachusetts Miracle." *Historical Journal of Massachusetts* 19 (Summer 1991): 111–32.

———. "Urban Renewal in Boston." *Historical Journal of Massachusetts* 21 (Winter 1993): 1–32.

Teaford, Jon. *The Rough Road to Renaissance: Urban Revitalization in America, 1940–1984.* Baltimore, MD: Johns Hopkins University Press, 1990.

———. *Unheralded Triumph: City Government in America, 1870–1900.* Baltimore, MD: Johns Hopkins University Press, 1984.

Thernstrom, Stephen. "Urbanization, Migration, and Social Mobility in Late Nineteenth-Century America." In *American Urban History.* 2d ed. Edited by Alexander Callow, New York: Oxford University Press, 1969.

Thompson, Margaret. "Ben Butler versus the Brahmins: Patronage and Politics in Early Gilded Age Massachusetts." *New England Quarterly* 55 (1982): 163–86.

Trout, Charles H. *Boston: The Great Depression and the New Deal.* New York: Oxford University Press, 1977.

Wakin, Edward. *Enter the Irish-American.* New York: Thomas Y. Crowell Co., 1976.

Walsh, Francis R. "The *Boston Pilot* Reports the Civil War." *Historical Journal of Massachusetts* 9 (June 1981): 5–16.

———. "John Boyle O'Reilly, the Boston Pilot, and Irish-American Assimilation, 1870–1890." In *Massachusetts in the Gilded Age*, edited by Jack Tager and John Ifkovic. Amherst: University of Massachusetts Press, 1985.

Walsh, James B. *The Irish American Political Class.* New York: Arno Press, 1976.

Wangler, Thomas E. "Catholic Religious Life in Boston in the Era of Cardinal O'Connell." In *Catholic Boston: Studies in Religion and Community, 1870–1970*, edited by Robert E. Sullivan and James M. O'Toole. Boston, 1985.

Ward, John William. "The Common Weal and the Public Trust." Forum 350, John F. Kennedy Library, Boston, October 21, 1980.

Warner, Sam Bass, Jr. *Streetcar Suburbs: The Process of Growth in Boston, 1870–1900*. Boston: Atheneum, 1973.

Warner, W. Lloyd, and Leo Srole. *The Social Systems of American Ethnic Groups*. New Haven, CT: Yale University Press, 1945.

Wayman, Dorothy. *Cardinal O'Connell of Boston: A Biography of William Henry O'Connell, 1859–1944*. New York: Farrar, Straus and Young, 1955.

Weinstein, Irving. *July 1863: The Incredible Story of the Bloody New York Draft Riots*. New York: Julian Messner, 1957.

Wells, Wellington. "Political and Governmental Readjustments, 1865–1889." Vol. 4 in *Commonwealth History of Massachusetts*, edited by Albert B. Hart. New York, 1930.

White, Anna MacBride, and A. Norman Jeffares, eds. *The Gonne-Yeats Letters, 1893–1938: Always Your Friend*. New York: W.W. Norton, 1993.

White, Patrick C.T. *A Nation on Trial: America and the War of 1812*. New York: John Wiley & Sons, 1965.

Whitehill, Walter Muir. *Boston: A Topographical History*. Cambridge, MA: Belknap Press, 1968.

Wittke, Carl. *The Irish in America*. Baton Rouge: Louisiana State University Press, 1956.

Woodham-Smith, Cecil. *The Great Hunger: Ireland, 1848–1849*. New York: Harper, 1962.

Zaitzevsky, Cynthia. *Frederick Law Olmsted and the Boston Park System*. Cambridge, MA: Belknap Press, 1982.

ABOUT THE AUTHOR

N*ew York Times* bestselling author, journalist, columnist and editor Peter F. Stevens has published fourteen books, including *The Voyage of the Catalpa*, which has been optioned for a feature film and was a chief resource for the docudrama *Irish Escape*. An editor at the *Boston Irish Reporter*, *Boston Irish Magazine* and *Scene Boston Magazine*, he has written for a wide array of magazines and newspapers in the United States, Ireland and the UK and has been syndicated by the *New York Times*. He is a two-time winner of the International Regional Magazine Association's Gold Medal for Feature Writing and in 2016 was honored by the Massachusetts legislature for his contributions to understanding the legacy of the Boston Irish. Specializing in overlooked Irish American, Irish and U.S. history, Stevens is currently working on a biography of John Boyle O'Reilly.